HERMÈS H08,
TIME, AN HERMÈS OBJECT

HERMÈS
PARIS

SLOW TRAVEL
Do less. See more.

Embark on an adventure with *Kinfolk* and embrace new sights, and new ways of seeing. Explore off-the-beaten-path adventures in *Kinfolk Journeys*, connect with nature in *Kinfolk Wilderness*, or plan your next escape with *Kinfolk Islands*. Guided by the idea that travel is as much about mindset as it is about itineraries, these books feature vibrant photography, practical guidance and thoughtful reflections. You'll find unexpected destinations for languid afternoons, entry points into awe-inspiring landscapes, and delightful road, rail and trail journeys from every continent.

Available on Kinfolk.com and in all good bookstores.

MASTHEAD

KINFOLK

MAGAZINE

EDITOR IN CHIEF — John Burns
DEPUTY EDITOR — George Upton
ART DIRECTOR — Mario Depicolzuane
DESIGN DIRECTOR — Alex Hunting
COPY EDITOR — Rachel Holzman

STUDIO

PUBLISHING DIRECTOR — Edward Mannering
STUDIO MANAGER — Vilma Rosenblad
DESIGN & ART DIRECTION — Studio8585
DIGITAL MANAGER — Cecilie Jegsen
ENGAGEMENT EDITOR — Rachel Ellison

CROSSWORD — Mark Halpin
PUBLICATION DESIGN — Alex Hunting Studio
COVER PHOTOGRAPHS — Carlos + Alyse
Michael Oliver Love

The views expressed in *Kinfolk* magazine are those of the respective contributors and are not necessarily shared by the company or its staff. *Kinfolk* (ISSN 2596-6154) is published quarterly by Ouur ApS, Amagertorv 14B, 2, 1160 Copenhagen, Denmark. Printed by Park Communications Ltd in London, United Kingdom. Color reproduction by Park Communications Ltd in London, United Kingdom. All rights reserved. No part of this publication may be reproduced, distributed or transmitted in any form or by any means, including photocopying or other electronic or mechanical methods, without prior written permission of the editor in chief, except in the case of brief quotations embodied in critical reviews and certain other noncommercial uses permitted by copyright law. The US annual subscription price is $80 USD. Airfreight and mailing in the USA by agent named World Container Inc., c/o BBT 150- 15, 183rd St, Jamaica, NY 11413, USA. Periodicals postage paid at Brooklyn, NY 11256. POSTMASTER: Send address changes to Kinfolk, World Container Inc., c/o BBT 150-15, 183rd St, Jamaica, NY 11413, USA. Subscription records are maintained at Ouur ApS, Amagertorv 14B, 2, 1160 Copenhagen, Denmark. SUBSCRIBE: *Kinfolk* is published four times a year. To subscribe, visit kinfolk.com/subscribe or email us at info@kinfolk.com. CONTACT US: If you have questions or comments, please write to us at info@kinfolk.com. For advertising and partnership inquiries, get in touch at advertising@kinfolk.com.

WORDS

Precious Adesina
Lamorna Ash
Lara Atallah
Mark Baker
Ed Cumming
Benjamin Dane
Daphnée Denis
Tom Faber
Salomé Gómez-Upegui
James Greig
Elle Hunt
Robert Ito
Tal Janner-Klausner
Tara Joshi
Farah-Silvana Kanaan
Kyla Marshell
Francis Martin
Ali Morris
Emily Nathan
Okechukwu Nzelu
Joann Plockova
Caitlin Quinlan
Manju Sara Rajan
Asher Ross
Apoorva Sripathi
Iman Sultan
Amanda Thomson
Tom Whyman

STYLING, SET DESIGN,
HAIR & MAKEUP

Michelle-Lee Collins
Tinbete Daniel
Chrisna De Bruyn
Von Ford
Amy Friend
Andrea Grande-Capone
Abigail Hayden
Alexa Hernandez
Thoreau Pedersen
Aliky Williams

ARTWORK &
PHOTOGRAPHY

Carlos + Alyse
Delfina Carmona
Erik Carter
Christian Cassiel
Rala Choi
Marina Denisova
Thomas Duffield
Cemal Emden
Patrick Fraser
Peyton Fulford
Richard Gaston
Maegan Gindi
Şakir Gökçebağ
Ekaterina Izmestieva
Cecilie Jegsen
Hallie Kathryn
Alixe Lay
Michael Oliver Love
Molly Mandell & James Burke
Sasha Maslov
Jack McKain
Charles Negre
Caroline Parkel
Peter Prato
Maria Ródenas Sáinz de Baranda
Bachar Srour
Armin Tehrani
Aaron Tilley
Vansh Virmani

PUBLISHER

Chul-Joon Park

RICHARD MILLE

RM 07-01 INTERGALACTIC

In-house skeletonised automatic winding calibre
50-hour power reserve (± 10%)
Baseplate and bridges in grade 5 titanium
Variable-geometry rotor
Case in Carbon TPT® set with diamonds
and 5N red gold prongs
Central dial in Carbon TPT® set
with 5N red gold prongs

A Racing Machine On The Wrist

WELCOME
The Faith Issue

Whether you believe or not, having a stance on religion is virtually unavoidable; people seek meaning, societies require order. A perspective on the universe and our place within it gives us a framework for understanding the world and informs how we live in it—regardless of whether it is secular or spiritual.

Whatever you think about religion—its dogmas and its miracles—it continues to shape our cultures, communities and cities. This issue of *Kinfolk* takes a look at just some of the ways in which it undergirds society and touches people's lives.

Over the course of several months, we documented the construction of a new Lutheran church in Denmark. Mindful of the building's longevity, the local parish asked some of the nation's biggest architects and designers to rethink how Christianity might be carried into the future. Elsewhere, Christianity's history comes under scrutiny—we speak to Ekemini Uwan, the public theologian holding the church accountable for its complicity in racial violence over the centuries.

We also meet two Jewish duos from opposite sides of the Atlantic: the Kleins, creators of the kosher food and travel magazine *Fleishigs*, and Sara Moon and Samson Hart, founders of Miknaf Ha'aretz, a community focused on Jewish land justice. Although they differ in many ways—one a suburban Chabad couple, the other a pair of back-to-the-land mavens—tradition unites them: Both made us a delicious Shabbat dinner.

In India, the Aga Khan Trust for Culture offers insight into religion's far-reaching influence, revealing how the preservation of historical and sacred buildings in the Muslim world can improve quality of life for diverse communities on a global scale. Meanwhile, a Buddhist monastic hones in on how a cosmic perspective might guide even the most mundane of daily chores, encouraging people to wash the dishes "as if giving the newborn baby Buddha a bath."

If, like me, you are an inveterate nonbeliever, you may relate instead to the many ways that faith has engendered human expression and creativity. We meet Ramy Youssef, the actor, screenwriter and director extraordinaire whose work is giving comedic nuance to the Arab American narrative—and who has almost every mainstream network clamoring to commission him. Or, consider David Lynch, the surrealist film director interviewed on page 18, who has meditated twice a day since 1973. It's simple, he says: "The key to all of it is, Does it make you feel better? Does it change your life?"

WORDS
JOHN BURNS

HOUSE OF FINN JUHL

Finn Juhl | 1945

The 45 Chair

When Finn Juhl presented the 45 Chair in 1945 at the annual Cabinetmakers' Guild Exhibition, the architect Erik Herløw wrote in his review of the exhibition:

"Most beautiful is an armchair where the frame is organically shaped like a bone, designed to support the muscles of an arm and the weight of a body. The expression of the chair is reminiscent of a weapon, sharpened by human hands."

Even today, the 45 Chair remains one of the most revolutionary and iconic pieces in Danish design. Discover the collection and all the stories behind: finnjuhl.com

H FJ

CONTENTS

14 — 36

STARTERS
Death, sex and David Lynch.

14	Free Spirit	27	Consider the Poster
16	Odd Jobs	28	What Are You Working On?
17	Cult Rooms	30	Still Life
18	David Lynch	32	Negative Capability
22	Object Matters	33	Against the Clock
24	Myisha Battle	34	Word: Tartle
26	Reality Check	36	How To: Have Lunch

38 — 96

FEATURES
On TV, rap and pilgrimages.

38	Ramy Youssef	64	Great and Small
50	At Work With: Child Studio	76	Aminé
60	On the Beaten Path	88	Home Tour: Vila Volman

"Interior design is art, it's history, it's more than just space." (Child Studio – P. 59)

08

ISSUE FIFTY-FIVE

Photo: Michael Oliver Love

Salone del Mobile.Milano

THOUGHT FOR HUMANS.

08–13.04 2025
FIERA MILANO – RHO

CONTENTS

98 — 160

FAITH
A leap into the spiritual.

98	The Altar of Design	134	The Church Owes a Debt
112	Kindred Spirits	142	The Long Arm of the Aga Khan
124	Coming in Hot! It's a Kosherpalooza	154	Life After a Leader

162 — 176

DIRECTORY
Wisdom, anecdotes—and a crossword.

162	Field Notes	170	Seasonal Produce
163	Behind the Scenes	172	Power Tool
164	On the Shelf	174	Credits
166	Crossword	175	Stockists
167	Received Wisdom	176	Point of View
169	Top Tip	—	—

String shelving system, made in Sweden.
Find a reseller in your region: stringfurniture.com/find-a-store

string®

Modern since 1949. Thousands of new combinations yet to be discovered.

STARERS

14	Free Spirit
18	David Lynch
27	Consider the Poster
28	What Are You Working On?
32	Negative Capability
36	How To: Have Lunch

14

STARTERS

FREE SPIRIT
The rise of God-neutral faith.

WORDS
FRANCIS MARTIN
PHOTO
RALA CHOI

As with GSOH ("good sense of humor"), SBNR—or "spiritual but not religious"—began as a way of describing oneself on early internet dating platforms. And, just like a belief in one's possession of a good sense of humor, SBNR is a pretty widespread phenomenon: Recent polls suggest that between a quarter and a third of Americans identify as "spiritual but not religious."

In the US and Europe, there has been a general shift away from the assumption that formal religious practice is the only mode in which to express spirituality. While religiosity in a traditional sense is declining—with much made of the 2021 census in the UK showing that, for the first time, less than half the population identified as Christian—there has not been an equivalent increase in people believing that the material world is all that there is. Despite predictions to the contrary, this crisis of faith has not handed a victory to materialistic atheism.

It appears, then, that it is not our instinct for spirituality that has changed, just its expression. While church attendance is significantly lower than it used to be, it is notable that belief in the existence of God and the power of prayer has not fallen by anywhere near as much. A self-described spiritual person today is more likely to find their connection to the sacred in nature rather than in formal religious services.

The communal aspects of religious observance have proven difficult to replace. There is no weekly meeting place for the spiritual but not religious, no liturgy they can chant, no community of like-minded people with a shared focus of devotion. Unless, that is, they're sports fans, in which case all these things are readily available, with chants replacing plainsong, and the stadium standing in for a cathedral.[1] A comparison can also be made between religious faith and a call to climate action: Both are undergirded by the claim of an existential truth that demands a particular response. For the Abrahamic religions, the claim is that God exists, and so we should worship Him; for climate campaigners, the world is imperiled, and so we must take action to save it.

Of course, neither dedication to the environment nor fanaticism for a sports team is a direct alternative to religion, but both contain elements of a spiritual commitment—belief in a greater good, in the service of which the self attains its true form through a process of sublimation. As it often is with the history of our species: Everything changes; nothing is new.

(1) The chant that fans of the British soccer team West Bromwich Albion use to show their support has a religious aspect: Since the 1970s, they have been singing Psalm 23, "The Lord's My Shepherd," as set to music by Jessie Seymour Irvine in 1871.

Unlike most funeral directors, Morgan Yarborough was not born into the business. "Nobody in my family has ever wanted to come close to this job," she says. Despite this, since graduating with a degree in funeral service management in 2016, Yarborough has done just about every job in "death care," from embalming and cremation to running a funeral home. She now works at Recompose, a Seattle-based funeral home specializing in human composting. The process, which was pioneered by Recompose, mimics natural cycles to transform human remains into soil and is gaining popularity in the US and overseas.

ELLE HUNT: What drew you to the job?

MORGAN YARBOROUGH: I've been told by childhood friends that I've always had an interest in death—I used to give pretty good funerals for my goldfish—but my family didn't like to talk about it. It was seen as this sudden, intense, emotional thing, and often I wasn't allowed to see my relatives after they died. I think that mystery actually propelled me to look more into it—to overcome my fear and understand it better.

EH: How have you seen the business change over the years?

MY: There are now so many amazing things on the progressive side of death care—like green burial, where you're buried in a shroud or eco-friendly casket. When that movement started becoming popular, my interests shifted there. I'm also lucky that I never had to work for commission, but the markups, and drive to get bigger sales—that's real, even in smaller funeral homes. Now I work for a nonconventional funeral home that aligns with my values.

EH: What makes a nonconventional funeral?

MY: A lot of our clients don't have a religious background or tradition, so we work with them to meet them where they're at. About 50 percent choose to have a funeral or viewing, just to spend time with their person, say their goodbyes and have that moment of connection. Music is a huge part of what we do: We've had everything from Celine Dion to Depeche Mode—I made a really great '80s rock playlist for a client the other day.

EH: You're the first funeral director to specialize in human composting. How does it work?

MY: It's different from any other option on the market. Green burial is awesome, but you're still taking up land in perpetuity. Our composting is done aboveground, in individual chambers. The process takes about eight to 12 weeks, and the result is a lot of really nutrient-dense soil—enough to fill a truck bed. Often our clients take a bit and use it for one special tree or plant, then donate the rest to our land program for use in conservation work. We've done a carbon life cycle assessment and there's definitely carbon savings.

EH: What has working in death taught you about life?

MY: I value my relationships on a deeper level, I think, because of my work, and I understand a lot more about what I want for my body when I die. It teaches you that nothing is promised, not even the next moment, so seize the day.

ODD JOBS
Morgan Yarborough, funeral director.

WORDS
ELLE HUNT
PHOTO
HALLIE KATHRYN

STARTERS

CULT ROOMS
A poetic space for rational prayer.

WORDS
SALOMÉ GÓMEZ-UPEGUI
PHOTO
CEMAL EMDEN

"Architecture is the building of worlds within worlds," said architect Louis Kahn at the dedication of the First Unitarian Church of Rochester in upstate New York in 1962. Hailing from a secular Jewish background and embracing broad, inclusive views on spirituality, Kahn was seen as a "natural Unitarian" by the church's building committee. His design sought to echo Unitarianism's expansive philosophy, resulting in a space that architectural critic Paul Goldberger praised as one of the greatest religious structures of the 20th century.

Constructed primarily from concrete and brick, the building embodies Kahn's devotion to monumentality—a concept he defined as "a spiritual quality inherent in a structure which conveys the feeling of its eternity." Central to his creative process was the careful modulation of silence and light, two elements Kahn regarded as essential to architecture's ability to inspire awe and reflection.

In the sanctuary, the heart of the church, four precisely positioned "light towers"—one in each corner—infuse the otherwise austere room with a natural light that evolves with the changing days and seasons. Elsewhere, thoughtfully placed light wells and window hoods capture and diffuse sunlight, creating contemplative spaces that invite both silent introspection and communion.

Surrounding the sanctuary is a corridor and the church school, an eccentric yet poetic arrangement that mirrors the spirit of inquiry central to Unitarianism. As Kahn explained, "It occurred to me that the sanctuary is merely the center of questions, and that the school was that which raised the question... and I felt that that which raised the question—[and] the spirit of the question—were inseparable."

DAVID LYNCH

WORDS
ROBERT ITO
PHOTOS
PATRICK FRASER

On the power of Transcendental Meditation.

David Lynch has meditated every day, twice a day, since 1973. He made time for it while directing *Eraserhead*, his debut film about a monstrous, incessantly mewling baby and the hapless man who fathered it, and while on the set of *The Elephant Man*, his 1980 drama about a severely deformed man in Victorian England. "I haven't missed a day in 51 years," he says.

In addition to directing a run of critically acclaimed films—including *Blue Velvet*, which earned him an Oscar nomination for best director, and the Palme d'Or–winning *Wild at Heart*—Lynch is a gifted painter, composer and cartoonist. He credits much of his creativity—and joy and energy and peace—to Transcendental Meditation (TM). Twenty minutes in the morning and the afternoon, he explains, is all it takes to begin realizing your full potential as a human being. "Most people waste way more than 40 minutes a day just goofing around."

In 2005, he founded the David Lynch Foundation, a nonprofit dedicated to increasing awareness about TM. On a call from his home in Los Angeles, Lynch discusses the foundation and its goals, how the practice changed his life and his deep love of smoking.

ROBERT ITO: How did you first come upon Transcendental Meditation?

DAVID LYNCH: My sister told me about it, but I'd been looking into all different kinds of meditations. People call almost anything meditation. Someone will say: My form of meditation is laying out in the sun. Someone else will say it's riding a bike through the park, or jogging, or a trip to the zoo. But then there's contemplation types of meditation, where you contemplate something, and concentration forms of meditation, where you concentrate on something. The key to all of it is, Does it make you feel better? Does it change your life? Some forms of meditation give more results than others. The key is consciousness, and in order to get more consciousness, you've gotta transcend. You have to go where the consciousness is. It's within. It's always been within.

RI: What does that feel like, to transcend?

DL: For me, transcending is like a jolt of bliss. You're in one place, and then you dip into the transcendent, the field of pure consciousness. It's like being plugged into an electric circuit; you get a jolt of happiness. It's very beautiful. And the more you practice this technique, the longer you stay in the transcendent. Short beautiful rides lead to longer beautiful rides, I always say it's like gold coming in and garbage going out. When you transcend and you've experienced this happiness, you have less stress, less depression, less sadness, less fear, less hate, less bitter anger—all negativity starts to dissipate the more you transcend. You start feeling better. You start acting better. You start enjoying more.

RI: If it's so beautiful, why do it only twice a day?

DL: It's like watering your lawn. You could water your lawn all day long, but it would erode it. You just need enough to make the grass green, and the rest of the time, you go about your business.

STARTERS

RI: Is there a special place you like to do it?

DL: No, you can meditate anywhere. People meditate in the strangest places, and noise is no barrier. I had one of my most blissful meditations next to a wall, and on the other side, they were jackhammering concrete.

RI: You wrote a book called *Catching the Big Fish*, where you liken TM to fishing. Do you fish?

DL: I do not fish. But I have fished, and I love fish. I just built a tail for a fish I got at a flea market. It was a mounted trophy fish, but it didn't have a tail. It broke off, I guess. So I had to build a tail for it.

RI: How is fishing like Transcendental Meditation?

DL: You just meditate the way you were taught, and take it as it comes. That's what the Maharishi Mahesh Yogi says: *Take it as it comes*. Never deny the validity of an experience if it happens, but don't try to replicate it, because trying is not going to work. It's a non-trying form of meditation.

RI: That sounds just like fishing.

DL: Yeah, exactly. You have to have patience. You have to have a place. And then you just close your eyes and do it.

RI: What are you doing nowadays, and how does TM help you do it?

DL: Well, here's the thing: I have emphysema from smoking, and so I am kind of homebound. And if I wasn't a meditator, if I wasn't transcending every day, I might be pretty miserable, not being able to walk very far without running out of oxygen. But I'm happy inside. I can do lots of things. I'm gonna start some new paintings. I'm working on the computer, and I've written a lot. Like I said, I built a fish tail—I've got a lot of little projects going. I'm not looking to retire. Life is really very interesting and great. For people who are still smoking, I want to say: Enjoy every puff. Every single puff. It's so great while you're smoking to enjoy that. I love tobacco. I love the smell of it. I love lighting cigarettes. I love the whole thing. Enjoy every single puff! But also know that your friend David, *he* enjoyed every single puff, but look at what happened to him. Now, some people don't get emphysema. You know, Harry Dean smoked for 75 years and didn't get emphysema, but he still got hurt by it.[1] It's something to think about, but it's a tricky thing, because that tobacco is awful nice.

RI: You created your foundation in 2005. Why did you want to do that?

DL: I didn't want to create it. It just kind of got created. It's called the David Lynch Foundation for Consciousness-Based Education and World Peace. Maharishi came with two goals: enlightenment for the people and peace on earth. The David Lynch Foundation just wants to help that happen, to get Transcendental Meditation to the people and help the peace-creating groups.

RI: In your book, you write about how TM can help kids. I was a pretty restless kid, and I can't imagine my younger self meditating. Would it have helped me?

DL: Robert, it would have helped us all. When you have consciousness-based education, you're giving kids a flak jacket to protect them from these stressful times. If kids would meditate regularly, it would be an incredible world. They would grow up to be incredible leaders and thinkers and doers, happy and strong. Negativity would flee from them. Flee. I think that world is coming sooner than you'd think, but that's just me. I'm an optimist. I have great hopes that a better world is right around the corner.

(1) Harry Dean Stanton was a longtime friend and collaborator of Lynch's, appearing in several of his films, including *Twin Peaks: Fire Walk with Me* and *Inland Empire*. A chain smoker, he once said, "I only eat so I can smoke and stay alive." He died from heart failure at the age of 91 in 2017.

OBJECT MATTERS
An icon of British modernism.

WORDS
JOANN PLOCKOVA

In 1948, New York's Museum of Modern Art held the International Competition for Low-Cost Furniture. The contest reflected an optimistic postwar belief in the power of design to improve quality of life, and saw the participation of some of the leading designers of the day, including Marcel Breuer and Charles and Ray Eames.

First prize in the storage category, however, went to two unknown British designers, Robin Day and Clive Latimer, for their innovative modular plywood system. The prize marked Day's breakthrough as a furniture designer and led to a collection commissioned by British company Hille in 1951 that included a stackable chair and a streamlined desk with a modular drawer unit.

The desk, together with its complementary chair, has recently been reissued by the Danish furniture brand &Tradition. In solid beech (with the option of a Fenix Nano laminate top), the &Tradition Daystak Desk maintains the light, utilitarian elegance of the original design—including the drawer's visible dovetail joinery and the collection's defining A-shaped legs—but has been scaled up by 2 percent for comfort. The depth of the rails running underneath the desk has also been reduced to ensure sufficient legroom, reflecting the efficient use of materials that came to define Day's practice.[1]

"He was in a way an environmentalist before the term was coined," says Paula Day, the late designer's daughter and the founder of the Robin and Lucienne Day Foundation. "From the beginning of his career, he believed in [making] minimal impact on the planet. He was very aware that the world's resources were limited. And that makes him an incredibly contemporary designer by today's standards."

(1) Day went on to pioneer the use of polypropylene, a type of plastic, in his design of the now-ubiquitous Polyprop chair, which was launched by Hille in 1963. "Rare is the human backside that hasn't found solace and support in Mr. Day's... famous creation," wrote *The New York Times* when Day died in 2010.

STARTERS

MYISHA BATTLE

WORDS
IMAN SULTAN
PHOTO
EKATERINA IZMESTIEVA

An expert's tips for better sex.

Myisha Battle remembers that when she was growing up in Shreveport, Louisiana, the sex education textbooks at her school were censored by black marker. Her quest for answers led her to become a clinical sexologist and sex and dating coach. She now hosts the KCRW podcast "How's Your Sex Life?" and is the author of *This Is Supposed to Be Fun: How to Find Joy in Hooking Up, Settling Down, and Everything in Between*. For Battle, the key to great sex is conquering shame, and it's this ethos, and feminism, that guides her practice.

IMAN SULTAN: How do you approach your work as a sex and dating coach?

MYISHA BATTLE: If you were a fly on the wall in my practice and in a therapist's practice, it would look the same. It's people in a room talking. [But while] therapy helps people look back in time at past patterns and traumas, coaching does a great job of looking forward, positioning the person where they would like to be. With individuals, it might be that they want to meet a person to settle down with, but they want to have great sex in the meantime. It's very action-based. I expect my clients to actually do things between sessions and come back to me with reflections on how things went, what tactics worked, what didn't. I tend to work with people for about three to six months but I have some clients I've been working with for years now. They are usually couples who are reworking the way they are in partnership with each other. That might look like working with a gender identity change, or an orientation identity change within the marriage or relationship. Or it could be opening the relationship, where each partner is dating, and I can be a support to them along the way.

IS: What inspired you to become a sexologist?

MB: I grew up in the South and I was encouraged to pursue the highest learning possible—except when it came to our sex education classes. I became a peer counselor and people would ask [me] a lot of questions about sex and dating. I didn't have the answers at 12, but I recognized there must be something that people were missing out on, and [that] they're craving. I've only had that reinforced throughout my life. When I was at San Francisco State University, studying health education, I focused on sexual health; when I told people, they would have a million questions.

IS: What do you love about your job?

MB: It's a weird job but it's something that I deeply identify with. I know there are other things that I could do, but I choose this because it is so gratifying. Sexuality professionals don't have it easy as business owners. We have to contend with shadow-banning and censoring just to get our message across, which is reflective of a very negative sex culture. It's not easy, but it's my calling and I really appreciate every day that I get to do the work that I do.

IS: What are your tips for having better sex?

MB: Talk more about sex. That's the number one thing. Productive sexual communication includes talking about desires, being okay when your desires do not align, and being able to talk things through: "Hey, I know you're really interested in this but it's not for me, right now. Or it's not for me, ever. And I still love and care about you."

IS: Why do you think there is so much shame about sex, even though it's such a normal part of our lives?

MB: We have tried to force [sex] to mean a bond between two people that leads to procreation. Anybody who is outside of that has to look at themselves in comparison to the "norm." I think there's this tension between holding sex as being so, so sacred, and the denigration of sex, that it's base, primal, you shouldn't give into it. You're gross if you do it. But I think we forget we created this tension, and that we can un-create it.

What would Hollywood be without the happy ending? Heroes saving the day, star-crossed lovers kissing in the rain, good triumphing over evil—these cornerstones of American cinema are so ubiquitous that they have become embedded in our cultural consciousness, clichéd tropes that are now an unavoidable expectation.

When adapting an existing story for Hollywood, ensuring its ending is a happy one is nonnegotiable, even if it requires making drastic changes to the original work. Take Truman Capote's somber novella *Breakfast at Tiffany's*, which became the definitive romantic drama of the 1960s in Blake Edwards' film adaptation, or P.L. Travers' acerbic literary Mary Poppins, who was transformed into the all-singing, all-dancing Disney version.[1] And it's still happening today—in the English-language remake of Danish thriller *Speak No Evil*, the original's grisly ending was made far more palatable, with the main characters managing to escape rather than meet a sticky end.

Mainstream, studio-produced films are often built from tried and tested templates. The three-act structure, with its curving arc from action to resolution, is synonymous with Hollywood screenwriting, and the happy ending is merely the last box to tick in this formulaic model. Narratives with sad, morally conflicting or traumatizing conclusions, like the original *Speak No Evil*, upset this balance; they defy expectation and leave audiences without the desired escapism or catharsis that often drives viewing habits.

"I don't know what it is about Americans, but they are brought up for a heroic tale, where the good must win over the bad, and this version of the film cultivates that," said Christian Tafdrup, the director of the original *Speak No Evil*, upon the release of the remake in 2024. For movie studios, such predictability makes good business sense—give the people what they want and they will continue to buy tickets. Yet, the cinematic landscape this fosters is uninspiring and unambitious. When we opt for the path of least resistance, we miss out on the shock finales, the letdowns, the unresolvable tensions that are valid and interesting conclusions in their own right, and reminders of film's poignant ability to reflect the realities of life back to us. Though catharsis might be tempting, it's the opportunity to experience something thornier and more complex—with an unhappy ending—that makes movies so invigorating.

(1) Truman Capote reportedly disliked the movie adaptation of *Breakfast at Tiffany's*, especially the casting of Audrey Hepburn as Holly Golightly, saying it was "the most miscast film I've ever seen. It made me want to throw up." Capote had wanted Marilyn Monroe for the role.

REALITY CHECK
The trouble with Feel Good.

WORDS
CAITLIN QUINLAN
PHOTO
AARON TILLEY

CONSIDER THE POSTER
In praise of a misunderstood medium.

WORDS
EMILY NATHAN
PHOTO
CAROLINE PARKEL

Poster art gets a bad rap. No matter the loftiness of its subject, the cachet of its artist or the sophistication of its graphic gesture, a poster will rarely elicit the same response as an original artwork. Produced en masse and procured online or from museum gift shops, they are often relegated to the status of disposable decor, destined to be tacked up with tape in dorm rooms or plastered on street corners next to portraits of lost dogs.

Indeed, when compared to paintings or expensive art prints, posters lack a certain dimensionality—quite literally, given they are usually printed on glossy paper without pores or fibers, smooth rather than tactile. There is no textured, breathing canvas; no dappled surface; no shadows to shift around a chunk of pigment as light moves across the room.

Yet the limits of medium belies the rich history of poster art, a genre that has for centuries been developing a distinct artistic legacy of its own. Since the advent of lithographic printing, which enabled their mass production in the late 1800s, posters have been used for purposes at turns mercenary, expressive and political, from Toulouse-Lautrec's vibrant vignettes of Parisian nightlife and Rodchenko's Constructivist Soviet designs to the more recent work of graphic designers like Paul Rand and Shepard Fairey, who was behind the iconic HOPE poster for Obama's first presidential campaign.

The accessibility of the poster, as well as its use in advertising, manipulative messaging and propaganda, has led some to view it as a lesser art form. But that is precisely what makes posters so essential: In their populist glory, they speak directly to us. They catch our eye on city streets, in bustling cafés or on subway walls; posters are defined by their ability to provoke double takes rather than more rarified pursuits. Their form—marked by iconic colors, graphics and typography that demands attention in a fleeting glance—*is* their function.

At their best, posters are art, unframed: bold enough to stop us in our tracks and flexible enough to move with us—the canvas of the masses.

WHAT ARE YOU WORKING ON?

WORDS
FARAH-SILVANA KANAAN
PHOTO
BACHAR SROUR

Sculptor NAJLA EL ZEIN.

The sculptures of Lebanese French artist and designer Najla El Zein are deceptively simple. Ranging in size from small glass objects to monumental ceramic and stone installations, they are the product of El Zein's extensive research into pushing the possibilities of whichever medium she chooses to work in. Solid and weighty materials take on sensuous curves, becoming soft and malleable, inviting you to reach out and interact with them—as with public commissions in Qatar, and work collected by the Dallas Museum of Art and the Victoria & Albert Museum in London.

FARAH-SILVANA KANAAN: You work between Amsterdam and Beirut—what are the charms and idiosyncrasies of each city?

NAJLA EL ZEIN: Growing up in Paris, then living for 10 years in Beirut, and now being in Amsterdam, I've always felt a sense of in-betweenness, of being in transit and perpetually rediscovering parts of me. As a result, the differentiation between cities has less of an impact, but there is a certain richness to Beirut—a chaotic energy and sense of embracing the present moment. Amsterdam holds this enchanting glow in its light, especially in late afternoons or after a rainy day when the light floods my studio, which I've started to become more and more attuned to.

FSK: Some artists in the Levant say they feel stuck in their hopelessness, others process their grief through their art. What do you see as the function of art in these times of turmoil?

NEZ: To me, art has the profound ability to connect people and provide a voice in the face of adversity. Life is about human connection, whether it's the sense of community you develop with craftsmen and co-workers, or the way people intimately relate to and respond to your work. I always intend to bridge personal and communal experiences through my work, and I believe that art can play a crucial role in uniting, unlocking resilience and providing hope.

FSK: What are you exploring in your work at the moment?

NEZ: My latest show, *Opacity, transparency, and everything in between* [at Friedman Benda gallery in New York], revolves around this sense of in-betweenness, which is a space filled with diverse, impalpable emotions, made up of fragments entangled with the present moment, almost impossible to grasp. I strive to decipher these fleeting moments, to objectify and render them eternal, mirroring both life and beauty.

FSK: Where do you want to take your practice next?

NEZ: My relationship with the materials I work with is continually evolving and I'm excited to deepen my understanding of glass and ceramics, which I've only recently begun exploring. I approach these materials with a sense of curiosity and wonder, eager to discover the possibilities they offer. I'm also looking forward to experimenting with other natural materials and uncovering the new creative opportunities they hold.

STARTERS

STILL LIFE
The case against growth.

WORDS
ELLE HUNT
PHOTO
CHARLES NEGRE

In 1972, a think tank named the Club of Rome published *The Limits to Growth*, a report predicting that if global populations and economies continued to grow exponentially, we would experience "a rather sudden and uncontrollable decline." The findings, which appeared to signal the end of the world, were widely dismissed upon publication; half a century later, their apocalyptic vision of the future is reportedly mere decades away from becoming reality.[1]

It is now overwhelmingly clear that we cannot continue at our current rate of production and consumption and that the plundering of finite natural resources has accelerated the risk of ecological and economic collapse; yet still we continue to push for more. Growth remains a key metric of economic performance, with countries and companies setting ambitious targets for increasing it. Consumer spending is continuing to rise and an avalanche of new products launch every day.

This unstoppable drive toward growth isn't just something we participate in as consumers; we've internalized its logic. Since the turn of the millennium—when Silicon Valley CEOs began to be celebrated for their "rise and grind" mindsets—working long hours has been worn as a badge of honor, and sacrificing a personal life, pleasure and rest seen as a fair exchange for professional progress. Today hustle culture demands that if you have hobbies, they must be monetized; you don't just post on social media, you build your personal brand. Online, we devour productivity tips from high achievers and seek insights from their punishing daily routines, hungry for any advice that we can apply to our own lives.

But it is not just our careers or financial position that we must improve—we are equally driven to work on ourselves, whether through products and services that claim to help us look younger and live longer, or with apps, online courses and resources that teach mindfulness, manifesting, a foreign language, or forgiving ourselves and others.

There is, of course, satisfaction to be had in setting goals and making progress toward them. But when the drive to do more and be better is so deeply culturally entrenched, it's not always easy to separate intrinsic and external motivation. Are we putting ourselves on a treadmill because we enjoy it, or because we've been led to believe we'd be revealed as unworthy if we don't?

Society pushes us to believe that there is a moral good in pursuing personal growth. The potential gains of continually striving for better, however, can belie the personal costs of doing so, and rob us of the opportunity to appreciate what we already have. Like the Earth, our resources—our time, energy, money—aren't infinite. But rather than seeing these limits as an unwelcome check on our ability and potential, we should instead learn to work within them and find new ways to expand ourselves and societies—ones that are sustaining, rather than extractive. Growth assumes that more is always better, but there's wisdom in learning to make do with enough.

(1) Speaking in 2022, half a century after the publication of *The Limits to Growth*, one of its authors, American physicist Dennis Meadows, reflected that we have failed to take meaningful action on unchecked growth. "As a result, we've passed beyond the Earth's capacity to support us, so the decline of our extremely energy and material intensive civilization is inevitable."

Let's face it: Reality is messy. Most of us exist in a haze of doubt and confusion, unsure of ourselves and our place in the world: Are we, at any given moment, doing the right thing? Are we living our most "authentic" life?

It is entirely understandable that some people might respond to this uncertainty with the conviction that there must be a fundamental grounding principle that can make sense of the mess and murk of our existence. It has preoccupied religious thinkers and philosophers for millennia. Think, for instance, of René Descartes, locking himself away in a heated room, trying to doubt everything until he came up with his famous maxim: "I think, therefore I am."

But the goal of absolute certainty is itself a very strange one. Descartes' own certainty came at the price of severing the "I"—which he could be certain of—from the entire physical world—which he couldn't be. There is indeed something about the very concept of certainty that seems so *lacking*, in the face of how dynamic everything actually is. One might think here of Kierkegaard's joke about the madman who, having escaped from an asylum, tried to convince the world that he was sane by only uttering things he could be certain were true, greeting everyone by stating "The earth is round! The earth is round!" It wasn't long before he was carted back to his cell.

Against this, it seems like it might be worth instead pursuing the intellectual virtue which John Keats called "negative capability": the capacity for "being in uncertainties, mysteries, doubts, without any irritable reaching after fact and reason." Keats particularly associated this virtue with Shakespeare who, he suggested, was able to convincingly inhabit the many characters he portrayed precisely because he was not attempting to communicate any specific, set, unified vision of the world through them.

What would it mean to practice negative capability in one's own life? Perhaps it's simply having a certain comfort with the messiness of existence—a determination to not be crippled by the thought that one either is, or isn't, ever doing the "right" thing. And an ability to celebrate, to wonder and not attempt to explain; to look at your child and think, "If I had decided to do something different in my life, even if it was 'better,' then this person might not exist." It is a way to realize that despite everything, there is really something very beautiful about the chaos of existence. Rather than try to find reason in it, we perhaps just need to embrace it.

NEGATIVE CAPABILITY
It's not that deep.

WORDS
TOM WHYMAN
PHOTO
AARON TILLEY

There is no shortage of statistics detailing how much time the average human spends on a given activity. The most reliable tend to be established along national boundaries: Americans spend around two hours per week in a grocery store; Austrians 82 minutes per day visiting friends; and the Irish lead the world in time spent volunteering and caregiving, doing so for roughly 132 minutes each day.

It's tempting to think that these statistics can give an image of the values and priorities of a given culture. Americans, for example, spend only 63 minutes per day eating and drinking, while the French spend more than twice that time at the table and consume far fewer calories. But other national truisms don't really bear out: Yes, Americans lead the developed world in hours worked annually (1,757), but that is only about three more hours per week than the famously balanced Swedes.

Similar surveys—many of which are commissioned as a form of viral marketing—promise to reveal something essential about the way we spend our free time. The annual *Nielsen Total Audience Report*, with relentless punctuality, informs us that we spend far too much time in front of screens (the average has risen to 12 hours, 20 minutes per day in the US). Reebok tells us that we will spend around 117 days of our lives making love. Kodak, bending their brand identity to a curious place, found that British men spend roughly 45 minutes each day gazing at women. Even something as innocuous as saying goodbye to people at parties has been totaled up (two days a year).

It is hard to read some of these statistics without a sense of protest. Some seem to cement clichés, and all of them can reduce the ebb and flow of daily pleasure, pain and meaning to a simple number. Averaged statistics about sleep cannot tell us who is dreaming richly, just as "screen time" cannot account for the difference between playing Candy Crush or watching *Citizen Kane*.

A spreadsheet of a person's nominal activities is a poor portrait of their inner life. We might spend three days a year waiting in line, but we are always fantasizing, reconsidering and wandering beyond the present. Take it from Harvard University, which once found that, whatever they are doing, humans spend about half their waking moments daydreaming. The most common time for a meandering mind? 11:20 a.m.

WORDS
ASHER ROSS
PHOTO
ŞAKIR GÖKÇEBAĞ

AGAINST THE CLOCK
What we learn, and lose, by tracking time.

WORD: TARTLE
Get better at forgetting.

Etymology: An old Scots word dating back to at least the 16th century, meaning to struggle to recognize an object or person.

Definition: Everyone tartles from time to time. It could be a momentary hesitation, unnoticed or easily ignored, or the prelude to the most uncomfortable exchange of your life. Tartling is not so much a problem when it's a one-to-one exchange: If someone greets you by name but you can't remember who they are, it's unlikely to arouse suspicion if you respond simply with, "Hi! Great to see you!" If your tartle persists beyond this point, however, you'll have to embark on the tricky task of turning detective without the other person realizing they are being interrogated. Some questions are more effective than others. Asking, for example, with a hint of rueful nostalgia, "So, who do you still see from the old crowd?" is likely to yield some helpful clues, even if "the old crowd" turns out to be a grandiose way of describing your former colleagues at a temporary admin job—those crazy hellions!

Keep it generic and it is entirely possible that you could make small talk in this way indefinitely—until, inevitably, someone else wanders over, forcing you to introduce your anonymous acquaintance. It will likely be far too late at this point to admit that you have tartled and you'll be left only with the choice between two different kinds of rudeness: 1) failing to introduce them at all or, 2) saying "and this is…," in the hope that they'll fill in the gap themselves. They probably will, but not before an excruciating pause in which the extent of your tartling is revealed. It might be preferable to fake a minor medical emergency.

Tartle is rarely used today, even in Scotland, but perhaps it should be.[1] Having a poor memory is not a moral crime, and forgetting who someone is does not necessarily mean they are not worth remembering. Perhaps if we were to revive the word and be able to name this experience, we would rob it of its power to embarrass and insult: Instead of embarking upon an elaborate deception to cover our tracks, we can just breezily admit our tartle, apologize and move on.

(1) Other obscure Scottish terms include *stravaig*, meaning to wander aimlessly; *beflum*, meaning to deceive, especially with cajoling language; and *sleekit*, meaning both smooth and glossy or sly and crafty, as in Robert Burns' poem, "To a Mouse": "Wee, sleekit, cow'rin, tim'rous beastie."

WORDS
JAMES GREIG
PHOTO
DELFINA CARMONA

KINFOLK

35

Everything that is great about lunch is unwelcome in the modern bustle. The idea of taking a couple of hours of pleasure in the middle of the day to eat is anathema to the always-online working world and—in the era of Ozempic and What I Eat In a Day posts on social media—the concept of a large feed seems indulgent to the point of grossness. That is before you have even considered the spectacle of drinking alcohol in the middle of the day. Between abstemious Zoomers and busybody puritanical bosses, even sniffing at a lunchtime drink feels like it could occasion the sack.

It is a pity. Lunch, performed with the correct liturgy, is one of our most civilized institutions. In *The Theory and Practice of Lunch* (1986), the journalist and playwright Keith Waterhouse makes a persuasive case that it is the finest meal of the day. He defines lunch as "a mid-day meal taken at leisure by, ideally, two people. Three's a crowd, four always split like a double amoeba into two pairs, six is a meeting, eight is a conference." While he allows that a "little light business may be touched upon," the occasion is "firmly social."

His principles still hold water today. A great lunch must have no more than three people. It must be at a restaurant that feels like an occasion without being stuffy: not the Ritz, not McDonald's, but somewhere in between. It is not a moment for diets—skip breakfast or dinner instead. Ideally it should be three courses, perhaps with dessert or cheese shared afterward. Drinking is not compulsory, of course, but those who want to ought to be encouraged: a martini or a glass of champagne to start and as many bottles of wine as required. No judgment.

Above all, Waterhouse knew lunch was an intimate thing, a secret snatched while the rest of the world was busy at its desk. He would have hated smartphones, no doubt, and demanded that there be no Whatsapping or Instagramming during the holy service. It is sound advice. Now more than ever, lunch is something to be fought for and jealously defended. "Whether they know it or not, for as long as they linger in the restaurant they are having an affair," Waterhouse wrote. "The affair is lunch." It's time to rekindle the romance.

WORDS
ED CUMMING
PHOTO
ARMIN TEHRANI

HOW TO: HAVE LUNCH
A practical guide to the prandial.

FEATURES

ram

Netflix. Amazon Prime. HBO. Hulu. Everyone wants a piece of *Ramy Youssef*.

Lara Atallah charts his unstoppable ascent.

Words
Lara Atallah
Photos
Carlos + Alyse
Styling
Von Ford

ny

(above)
Youssef wears an outfit by SACAI.

(opposite)
He wears an outfit by BOTTEGA VENETA.

(previous left)
He wears a jacket by BOTTEGA VENETA.

(previous right)
He wears a jacket, shirt and trousers by SACAI and shoes by BOTTEGA VENETA.

Ramy Youssef has never encountered a blank page he wasn't excited to fill. Whether he's performing stand-up, hosting late-night shows or creating and starring in award-winning series, the prolific 34-year-old multihyphenate never seems to be short of inspiration, mining his experience growing up as an Arab American and the stories of his community.[1] Like the leading role he created and played in *Ramy*, the Hulu series that earned him a Golden Globe in 2020, Youssef also grew up in New Jersey, the son of Egyptian immigrants, and his routines, characters and collaborations with fellow actors, writers and directors have been informed by a compassionate response to the often challenging experience of Muslim Americans post-9/11.[2]

Yet his work is also a humorous reflection of everyday life. In *Ramy*, Youssef's character moves from being an aimless 20-something living at home, desperately seeking a sense of purpose he can't seem to find, to being a businessman and a father with responsibilities that force him to grow out of his recklessness. Embracing his Muslim background, he turns to faith, in what becomes a protracted search for God, albeit it with many detours down less than holy paths.

Ramy the actor and Ramy the character had less and less in common with each other as the seasons progressed (Youssef admits to regretting naming the character after himself) but what they share is a need for faith as an anchor and a compass, tools to navigate a world that is leaning further right. "The show was designed as a way to take this character and put him on a spiritual path," he says. "I always knew in the back of my head that it would probably not do the same to me. If anything, the gap was kind of growing further as we continued making the show."

"The thing that the real world really affected was tone," he continues. "I wanted to be flexible, with each season feeling like a year of the character's life. So you have some years that feel a little happier, some that feel darker, and then some years where, you know, you're kind of blossoming."

"Blossoming" is also a good way to describe Youssef since *Ramy* took a hiatus after the third season aired in 2022. When we meet on an unseasonably warm November day in Brooklyn, he is preparing to launch a new animated series through A24, capping a year that has seen him host *Saturday Night Live*, release a second stand-up special on HBO and enter into a creative partnership with Netflix to develop new projects through his own production company, Cairo Cowboy.[3]

(1) In his first stand-up special, *Feelings*, Youssef talks about how his father once worked at a hotel in New York owned by Donald Trump, recounting how his father had hidden a photo of himself shaking hands with Trump because he didn't want Youssef to use it as comedic material.
(2) When it first aired in 2019, *The New York Times* described *Ramy* as a "quietly revolutionary comedy" for its sympathetic portrayal of Muslims on screen.

KINFOLK 41

43

Even after a daylong photo shoot, Youssef is smiling and happy to chat. He explains that, as a practicing Muslim, whether by way of the divine, or through humor, he sees spirituality as an agent for hope, which he channels through his various creative endeavors. Playing a British scientist alongside Emma Stone and Willem Dafoe in Yorgos Lanthimos' outrageous *Poor Things* does not deviate from that goal—it was his first major movie role, and a welcome change of pace from his usual projects—and Youssef makes it a point to clarify that he does not see the idea of only playing Arab roles as limiting in any way. To him, there's so much to explore.

He gives the example of *Ramy*. While the character on the show is "both the butt of the joke and the butt of the issue," he says the real stars are the cast of supporting characters, which opened up a rich tapestry of storylines about the Arab American experience beyond struggles of assimilation. His characters' arcs took the series in different directions, and he was happy to follow. "So much of it," he says, "is an organic experience based on how great the cast is." It's a testament to the camaraderie Youssef fosters on set and his openness toward fellow cast members sharing their own insights, perspectives and lived experiences.

"The show was designed as a way to take this character and put him on a spiritual path."

Whether as an actor, comedian, screenwriter, producer or director, Youssef's desire to showcase the imperfections of human nature and the fundamental similarities that bind us all, regardless of our respective backgrounds, gives his work broader appeal.[4] He shows his audience the multiplicity of ways one can be an American, how citizenship transcends a pledge of allegiance and boils down to being a part of a community that bonds over shared universal values.

And so it is with sadness that he says that the past year has shown him how the ghost of the 9/11 era—when Arab Americans were routinely demonized—has resurfaced.[5] It's a situation that has reframed his perception of his new animated series, *#1 Happy Family*

(3) Youssef's appearance on *Saturday Night Live* included sketches like "Immigrant Dad Talk Show," "Ozempic for Ramadan," and "The Hitman," where he plays a hitman about to take a shot, repeatedly interrupted by his UberEats delivery driver.
(4) In addition to directing episodes of *Ramy*, Youssef was nominated for a Primetime Emmy for "Honeydew," an episode of *The Bear* set in Copenhagen.

(above)
Youssef wears an outfit by
FERRAGAMO.

(previous and overleaf)
He wears a jacket and trousers by
GCDS, a shirt by NANUSHKA,
shoes by BOTTEGA VENETA and
his own glasses.

USA, which launches this spring on Amazon Prime—a show Youssef jokes was gestated, developed and birthed through both Trump administrations. The series centers on a Muslim family in America in the direct aftermath of 9/11. Finding themselves under much suspicion and scrutiny, the characters embark on an elaborate journey to prove to their neighbors that they are the happiest, most unthreatening family in America by mastering the art of code-switching as a means for survival within a hostile environment.[6] "The funnest part was composing music and doing different voices, exploring the father character's inner folk musician—imagine an Egyptian Bruce Springsteen," he says. Fostered through a collaboration with artist Mona Chalabi and starring Alia Shawkat, Youssef had initially believed that the show would feel like a time capsule from a bygone era the world had moved past and learned from; he has since realized he had been out of touch with the reality on the ground.

While his work is a product of the stigma that has surrounded his community, his aim is to bring more people into the fold, exposing identity as a fragile concept. As someone who lived through the post-9/11 era as a child in New Jersey, Youssef remembers fearing himself, wondering if what he heard was true, whether he too was dangerous. "I was afraid: All the names and faces that were plastered everywhere seemed really similar to the names and faces in my family," he says. But in the midst of it all, he also saw the discrepancies between other people's perception of his community and the reality of who these people were, and the values with which they moved through the world. "If you let the definition being provided stand, you're done," he says. "For a lot of people who have family in the Middle East, we've been dealing with a dehumanization problem for a long time. That has been unfortunately very bipartisan: There's the looming threat of the new administration, but it was already happening with the old one," he says. "Time will tell where we stand."

As the co-creator and a writer for the Netflix series *Mo*, Youssef saw an opportunity to bring the story of a Palestinian family in America to the television screen in 2022—long before the Israel–Hamas war erupted. With humor that echoes *Ramy*, *Mo* thrusts viewers into the world of the Najjar family, who are Palestinian refugees caught in the net of endless immigration bureaucracy, incompetent lawyers and a longing for a homeland which, from Texas, seems far away.

Youssef is determined to resist distraction brought on by news cycles. When asked whether the war might influence the direction of his future projects, he says he would prefer to channel his focus and energy into his current ones. There are stories to be told, and production schedules to move through. The work of telling important stories continues unabated, and it is more important now than it ever has been.

(5) In the last quarter of 2023, the Council on American-Islamic Relations received more than 3,500 complaints of alleged Islamophobia, an increase of nearly 180 percent compared to the same period the previous year.

(6) Code-switching is the act of adapting one's appearance, speech or behavior in different social settings—often by minority groups to ease interactions or accommodate the comfort of the majority.

KINFOLK

Speaking with Youssef, it is easy to feel like you're chatting with an old friend and his enthusiasm encourages conversation to flow. Success to him is a by-product of moving authentically and unapologetically through the entertainment landscape with the willingness to engage in conversations and reach agreements that do not take away from his values or the essence of his projects. In his opening monologue on *Saturday Night Live*, for example, he talked about praying for his friend's family in Gaza: "God—please... stop the suffering, stop the violence, please free the people of Palestine, please free the hostages...." It was received with cheers from an engaged audience. In the same vein, his controversial red-carpet appearance sporting an "Artists for Ceasefire" pin, to signal his opposition to Israel's relentless attacks, was intended to make a statement he believes needs to be made loudly and unambiguously. It was inevitably met with criticism online, with some people believing this gesture to be empty and performative, and others claiming it to be inflammatory and divisive.

But Youssef believes that the best thing about being an artist and an adult is the ability to stand firm on his principles—to free oneself from the need to code-switch, and call people in through good spirits and an inviting smile. His approach has set a new standard. In his wake, new names and faces, such as Emil Wakim and Nataly Aukar, have emerged on the scene, layering their own experiences as members of the same community on top of his. Even though, in many ways, Ramy Youssef is only just getting started, it already seems that his impact on pop culture will be the doors he is opening for others.[8]

"If you let the definition being provided stand, you're done."

(7) *Mo* is loosely based on the life of American Palestinian comedian Mohammed Amer, who also appears in *Ramy*. The series has received critical acclaim, holding a 100 percent approval rating on Rotten Tomatoes.

(8) Youssef chose a song by '70s Egyptian pop band El Masreyeen as *Ramy*'s theme. The band's founder, Hany Shenouda, credited the show with sparking a resurgence in their music and even renamed the song "Ramy," which Youssef found surreal, as his parents had heard it during soccer games as kids.

FEATURES

AT WORK WITH: Child Studio

Words
Ali Morris
Photos
Alixe Lay

Nestled in a quiet, cobbled courtyard in central London, the unassuming modern facade of Child Studio's office gives little away. Venturing inside, however, feels like stepping into a film on pause: the book lying open on a side table, the scent of leather and tobacco lingering in the air, the carefully selected objects.

This sense of layered storytelling will be familiar to those who know Child Studio's work. Founders Alexy Kos and Che Huang create interiors that feel like movie sets—cinematic, moody and steeped in design history. Their portfolio is as varied as it is atmospheric: The conversion of a 1960s post office into a sushi restaurant that pays homage to mid-century Tokyo; an eyewear store that channels the louche history of London's Soho; a Belsize Park apartment that references the Bauhaus era. Each project transports you to a distinct time and is layered with cultural references that feel at once familiar and enigmatic.

The studio's office is an extension of this ethos. The space has been bestowed with the warmth of a well-curated home. Mahogany library cabinets wrap the walls, hiding the angular glass partitions of the modern building beneath. Collectible pieces from the '30s, '60s and '70s—by Jacques Adnet, Charlotte Perriand and Charles Rennie Mackintosh, to name just a few—are placed with precision, lending the room a certain timelessness. Sculptures, books and art hint at a life rich in design and travel, while two

" The idea is to create spaces that feel as though they've evolved naturally over time."

large HAY Mags sofas are placed around a bespoke maple coffee table and polished plaster fireplace.

Here, Child Studio's effortless style is on full display. "The idea is to create spaces that feel as though they've evolved naturally over time," explains Kos of the studio's approach. "They should feel organic and adaptable, not confined to a rigid style. A space that people can use as a backdrop to their life."

The duo works from a smaller study area tucked away to the right of the entrance, surrounded by reference books and beautiful artworks that inform their process. Daylight is limited but more than compensated for with table lamps and sconces—another distinguishing feature of their work. "We like shadows, and we also like gloomier rooms," says Huang. "[People] tend to want to paint them very bright but we do the reverse—make them dark and cozy. In a darker room, you appreciate the light much more—you notice it."

"Lighting is one of those things that is impossible to design virtually," he adds. "You need to see the space and play with it." The starting point for every Child Studio project is a thorough investigation of the site, its location and its history. "There will always be an interesting story there, and then it's about finding the angle. We look at books and dig deeper into a subject, looking at artists and architects that we admire. It's how we create a layered, lived-in effect."

To demonstrate, Huang shows sketches and work-in-progress imagery of the Twenty Two, a hotel in New York's Flatiron district (the original Twenty Two, designed by Natalia Miyar, opened in London in 2022). Child Studio's interiors pick up on the Romanesque revival style of the building's facade, incorporating Jacobean, Victorian and American colonial elements into what had originally been a YMCA founded in 1891 by socialite Margaret Louisa Vanderbilt Shepard. "It was previously used as an office building and all the interior features had been ripped out, so it was really about starting from scratch," says Huang. "The facade is so beautiful—we wanted to create a fantasy of what could have been there in that era. When you go and stay at a hotel, I think you want a little bit of theater and atmosphere: an experience."

Creating these transportive environments without tripping over into pastiche is something Child Studio excels at. It's the quality of the materials—primarily stone, wood and metal—they explain, that bring authenticity to the journey. The Twenty Two in New York is filled with hundreds of bespoke pieces of furniture, all designed by Child Studio and made by their network of skilled craftsmen—in this instance in the Veneto region of Italy. "That's part of the fun of our job," enthuses Huang. "A lot of the time there are unexpected collaborations." Other fixtures and furniture pieces are carefully selected from antique dealers or vintage fairs or unearthed on auction sites, which Huang admits are something of an obsession for him. "Some of the pieces aren't even necessarily expensive, they're sourced on eBay, which is so good in the UK. It's kind of a furniture education." For artworks, they frequent auction houses Christie's and Sotheby's, and have become sought-after art advisors.

The pair are deliberate about avoiding trends—you won't find them in a bidding war over the Pierre Jeanneret chairs of the moment.[1] Instead, they'll be looking for something less obvious: a Mackintosh-inspired Arts and Crafts–era chair, for instance, from a lesser-known, emerging antique dealer. "There's a bit of a movement, I think, in London, with the emergence of small, independent antique dealers who are forging their own path," observes Kos. "A lot of them are younger; they curate their selection according to their own unique point of view."

> " I think you want a little bit of theater and atmosphere: an experience."

Instagram has been a useful tool for Kos and Huang. It's where many clients come across their work, attracted by their nostalgia-tinged aesthetic. So far, the strategy has worked well, and Child Studio has found both private and commercial clients who appreciate their punctilious yet collaborative approach. "I think it's the atmosphere we create that attracts clients, rather than any specific style," says Kos. "They don't really care what period an interior evokes, it's more about creating a certain feeling, and I think that's how we look at it too. It's our job to make sense of exactly what it is that they want."

Kos and Huang believe that their diverse cultural roots—Huang's in Taiwan and Kos' in Russia—give them a distinctive perspective and an easy ability to juxtapose styles and eras in their designs. Huang, the son of an architect, had initially dreamed of becoming a manga artist before pursuing furniture design. Kos' training in interior architecture at the Stroganov Academy in Moscow sparked a passion for craft—the six-year program had workshops in glassblowing, ceramics and metalwork—which is now reflected in the studio's work.

KINFOLK

" You don't need anything new to have a very new-looking space."

FEATURES

Meeting as students at the University of the Arts London, they quickly discovered a creative synergy. During Milan's 2017 Salone del Mobile, the pair debuted their first joint project—a lighting collection informed by the paintings of Giorgio de Chirico—before formally launching Child Studio a year later. The name, they explain, is a nod to Childs Hill, the area of north London they were based in at the time, but also references the childlike sense of wonder and fresh perspective that they hope to bring to their work. They particularly enjoy the famous Isamu Noguchi quote, "When an artist stopped being a child, he would stop being an artist," which greets visitors to their website.

Small-scale interior projects gradually grew in size and scope. Their first project with Navid Mirtorabi, the owner of the Twenty Two, was a vegan pizza place in west London that they playfully wrapped in bubble gum–pink Formica. "Since we started working for ourselves, it's been a really fun journey," says Huang. "And we're still having fun, because every new project is different. We still feel like we are learning every day. One day we'll be going to an auction to buy art, and then the next we go to a factory to look at furniture being made."

Kos and Huang don't have a team. Instead, they handle every aspect of their projects personally to ensure they can deliver the level of care and attention their reputation is built on. As a result, their work and life are inseparably intertwined—a continuous creative process with no clear boundary between the two. "It's all-encompassing," says Kos, reflecting on their journey. "Interior design is art, it's history, it's more than just space."

When we meet, the New York outpost of the Twenty Two is about to open and the final installations and adjustments are occupying much of the studio's time. Since they created so much furniture for the project, I ask if a Child Studio furniture line might be on the horizon. Huang and Kos are dubious. "Maybe eventually," says Huang. "But I think only when we find the right people or workshop to partner with."

Kos agrees. "Creating furniture feels right when we design it for a project, because it's very particular, fulfilling the requirements of the space," he says. "We know that it will be used and loved. Whereas, if we design pieces that aren't for a specific space...." he trails off. "We just hate the idea that we might create something that would pollute the world." For now, the duo agree that people should be buying vintage or secondhand pieces. "You don't need anything new to have a very new-looking space," says Huang.

As for what they are excited about in the near future, it's the thrill of working with new, unique locations—they have recently started working on residential projects in the US, France and Hong Kong. Each project comes with the opportunity to explore uncharted localities, work with clients who share their vision and apply their immersive approach to spaces around the world, each one a fresh canvas for storytelling. "We aspire to create effortless and understated spaces, and this approach relies on subtle differences in materiality and detailing that only passionate and knowledgeable craftsmen can provide," explains Kos. "As a result, our work has been evolving towards a certain quiet confidence—interiors that feel lived-in, relaxing and spontaneous."

(1) The trend for Chandigarh chairs has highlighted the erasure of Indian architect Eulie Chowdhury, who collaborated with Pierre Jeanneret on its design. According to the research organization The Chandigarh Chair, "Jeanneret's attribution has allowed the furniture to be rooted in the European modernist canon by the international art market."

Essay: ON THE BEATEN PATH

On the revival of pilgrimage.

Words
Francis Martin

Nine hundred years ago, a small boat moored on the jagged coastline of Orkney, the largest landmass in a windswept archipelago off the north coast of Scotland. Back then, it brought the body of a man revered as a saint; today the ferry that plows the same cold, shifting sea brings pilgrims who have set out to follow the route along which the saint was carried to his final resting place.

Tall stones were once erected at the points where the coffin-bearers paused to rest, but only a few of these remain. Recently, however, those who wish to follow in their footsteps have had an alternative: an app which guides the modern pilgrim along the St Magnus Way, with checkpoints announced by a volley of bagpipes.

The app—and the reinvented route—come amid a resurgence of interest in pilgrimage. Historic Christian routes in Europe, such as the Camino de Santiago in Spain and the Via Francigena, which runs from Canterbury in the UK to Rome, are seeing record numbers—over half a million completed the Camino in 2023.

And it's not just the numbers out on the road that are impressive. A recent survey commissioned by the British Pilgrimage Trust (itself founded only a decade ago) found that almost a fifth of 18- to 64-year-olds in the UK had considered going on pilgrimage. The co-founder of the trust, Guy Hayward, attributes the revival to the way pilgrimage can "answer a lot of the issues we have today: mental health, connection with the land, connection with nature and the need to reorient our lives to something with more purpose and meaning." Post-pandemic, and amid growing anxiety about the climate, it seems that more of us than ever are seeking to reengage with nature and find meaning in life. "Pilgrimage is very good at integrating all the vast changes we're experiencing right now, and giving us space to catch up," says Hayward.[1]

" It relates to the principles of the cosmos: You could say that the planets are making a pilgrimage around the sun, salmon are making a pilgrimage back to their place of birth."

The spiritual side of pilgrimage is open to everyone, Hayward suggests: It can act as a "beginners' practice" for those who are exploring spirituality for the first time, but also as a "whole new way of engaging with your faith for people who have a well-established religious identity." Information boards dotted across the St Magnus Way in Orkney make clear that although it is "rooted in the Christian faith" the route "welcomes all people and faith perspectives." The app offers historical information along with poems, reflections and a focus for contemplation for each of the six stages of the pilgrimage, which include loss, growth and change. One could use the resource simply as a hiking trail with added cultural context, and perhaps some do: At St Magnus' Cathedral, where the pilgrimage ends, there is a station set up for those who have completed the route. A few recent entries in the logbook focus on the natural beauty and cultural insight that it offers. "A wonderful tasting platter of all the loveliness of Orkney," one comments. A German couple are less effusive: "Impressive path."

IT GIVES THEM PEACE OF MIND, IT'S THERAPEUTIC, IT'S OUT IN NATURE.

Kamya Buch, a content creator and spiritual educator in the Vedic tradition, explains how people can benefit from following pilgrimage routes even if they're not explicitly engaging in devotional practices. The synergy of nature and the spiritual in many religions means that, "even if they're not aware or there's not any external symbols, there is a spiritual calling of that river, for example." Many of the holiest sites in the Indian subcontinent, such as Pushkar Lake and the Ganges river, are natural phenomena. Mount Kailash, in Tibet, is considered sacred by Hindus, Buddhists, Jains and Bönpos, who make pilgrimage around it (the latter walking counterclockwise, while the others travel clockwise).[2]

For Buch, the significance of *yatra*—the Sanskrit term for pilgrimage—lies in the way that the ritual enables a shift in consciousness. A pilgrim, she says, "gets a deeper experience of that land, they get a deeper experience of the change they were already seeking. Most people hike because it gives them peace of mind, it's therapeutic, it's out in nature; pilgrimage gives them an added layer to understand the spiritual properties of a particular place. The most popular hiking routes in the US, such as the Appalachian Trail, are often walked with the kind of intention and openness to change that distinguishes a pilgrimage. "They're being repurposed by people who want to bring a more conscious journeying element to the walk," Hayward says. Along with introspection and an engagement with the landscape, this includes the communal aspect of pilgrimage, born of interactions between locals along the way and conversation with fellow pilgrims.

Another entry in the St Magnus Way logbook, written by a group of three people, points to the importance of this aspect: "We made sure the main thing was kept the main thing: fun, fellowship and journeying together." Many find that walking together, with a shared goal, creates a kind of community on the road, in which the social hierarchies of normal life are broken down; that something new can be built from the "rhythm" of pilgrimage, as Hayward describes it, in which one walks sometimes together in conversation, other times alone, and often in companionable silence.

The community that develops during a pilgrimage can be a source of meaning in itself, leading to conversations that help to illuminate motivations that the pilgrims may have been ignorant of. Victoria Preston, in her book *We Are Pilgrims*, writes that "our impulses toward pilgrimage are a brocade of interwoven strands, some glimmering clearly, others invisible even to ourselves." A pilgrim might set off with a clear sense of their purpose but then out on the road discover a meaning in the journey, or an aspect of themselves, that they had not anticipated.

For Hayward, the urge to embark on a pilgrimage is a fundamental one: "It relates to the principles of the cosmos: You could say that the planets are making a pilgrimage around the sun, salmon are making a pilgrimage back to their place of birth."[3]

The invocation of salmon, often characterized in folklore as the oldest and wisest of creatures, highlights an aspect of pilgrimage that is often overlooked: the journey home. Returning after being transformed by physical and mental trials, and the interactions with the people you meet along the way, is an archetype present in the literature and folklore of all cultures and in all ages. While pilgrims might focus on their outbound journey to a particular site—be it a cathedral, temple, mountain or body of water—it is the act of coming home that ultimately forms their self-transformation. Perhaps the hallmark of a pilgrimage is not so much what you do on the journey, but the person you are on your return.

(1) In his 2024 book, *Mysticism*, philosopher Simon Critchley explores the resurgence of interest in mystic practices during the pandemic. He observes: "It was as if something archaic—elemental, primeval and long dead—awakened in the plague. Some began to wonder about the nature of these archaic feelings and how they might understand the mysticism that had revived, like some unbidden ghost."

(2) Climbing Mount Kailash is regarded as sacrilegious, and there have been no known successful ascents. Italian mountaineer Reinhold Messner was offered the chance to climb it in the 1980s by the Chinese government, which controls the area as part of the disputed Tibet Autonomous Region. He declined, saying, "If we conquer this mountain, then we conquer something in people's souls."

(3) Folklore has long held that salmon return to the exact stream where they spawned. Studies have shown this is largely true, despite salmon spending between one and five years in the ocean. It is believed they use an acute sense of smell to locate the stream once in the estuary of a river and rely on the Earth's magnetic field when in the open ocean.

Fashion: GREAT AND SMALL

Photos
Michael Oliver Love
Styling
Chrisna De Bruyn

(below) Campbell wears a suit by AKJP STUDIO.
(opposite) He wears trousers by AKJP STUDIO.
(previous) Skye, Campbell, Daiyaan and Kayla wear outfits by VIVIERS STUDIO.

Models: Campbell Ibuma & Daiyaan Marshman at Full Models, Skye Metrowich at Boss Models, Kayla at Topco Models.

(below) Daiyaan wears an outfit by RICH MNISI.
(opposite) Kayla wears a dress and Skye wears a jacket by THEBE MAGUGU.

(above) Campbell and Daiyaan wear trousers by AKJP STUDIO.
(opposite) Daiyaan, Kayla, Campbell and Skye wear outfits by KLŪK CGDT and KIMONO & SILK.

(below) Campbell wears an outfit by VIVIERS STUDIO.
(opposite) Kayla wears a dress by THEBE MAGUGU.

(below) Daiyaan wears a shirt by AKJP STUDIO.
(opposite) Daiyaan wears a shirt by AKJP STUDIO.

Aminé quit college to step into the spotlight with his "Vitamin D" genre of rap. Three studio albums, four mixtapes and five billion streams later, he's still shining.

am

Words
Tom Faber
Photos
Erik Carter
Styling
Tinbete Daniel

iné

Aminé is a certified Good Time.[1] Despite being in danger of missing a flight to Japan, he's all smiles, his eyes sparkling over our video call. He makes it into a cab and settles into the back seat. The sunroof bathes him in the warm California morning sun. Beneath his mint green headphones and oversized navy hoodie, he looks like he's rolled straight out of bed: black beard wispy and untamed, a couple of stray dreadlocks hanging down beside his face.

"I don't know many people in Tokyo," he says in a gentle West Coast accent. "I like to be somewhere I can just hone in, be alone and focus on writing." His new album is almost done and he needs to push it over the line, so he's traveling to Tokyo to put his head down and focus. Fans have been waiting for five years and no one knows what to expect—his previous three albums have all had a different sound, each a unique fusion of hip-hop with pop, R&B and dance.

Aminé first gained acclaim not just for his technical proficiency as a rapper, but for the infectious sense of fun he brings to his music and videos. He has been classed alongside a new guard of musicians like Chance the Rapper, Lil Yachty and Tyler, the Creator, who are bringing color and goofiness to the sometimes serious world of rap. It's a vibe he clearly telegraphed on the cover of his debut album, 2017's sun-soaked *Good for You*, where he sits naked on a blue toilet set against a canary-yellow background.[2]

(opposite and previous)
Aminé wears a hat by ABELA023, a jacket, shirt and trousers by BLUEMARBLE and shoes by OUR LEGACY.

"There's a bit of imposter syndrome.... I never really had a blueprint."

Yet despite the smiles, despite the millions of followers on social media, the platinum records and billions of song streams, Aminé feels insecure—and he's disarmingly candid about it. Just minutes into our conversation he says, "When you're in the studio you can drive yourself crazy; you start to think: 'Man, do I suck?'" He smiles. "Which is funny because I'll watch other artists talking about staying confident and staying on your path, and that honestly is so much easier said than done. I think the bigger you get, the harder it is to believe in yourself, in a way. It's like the bigger I get, the easier it can all come crumbling down."

Where do these feelings come from? "There's a bit of imposter syndrome," he explains. Aminé grew up in Woodlawn, northeast Portland, far from the hip-hop capitals of the US. "I didn't have anybody I knew that had done what I'd done before," he says, "so I never really had a blueprint for that."

(1) Aminé is the stage name of Adam Aminé Daniel.
(2) The newspaper Aminé is reading on the cover is *The Good For You Post*—a real publication he produced and distributed to fans at pop-ups in LA and New York City. It addresses topics as diverse as gentrification, supernovas and skating, includes recipes and a word search, and features an article written by his mother.

That's not to say he lacked a strong musical education—Aminé's parents, who moved from Ethiopia to the US in 1990 (his mother is Ethiopian, his father Eritrean Ethiopian), played Ethiopian music at home, alongside the albums of Bob Marley. But Aminé credits his mom with getting him into a wider variety of music. He remembers sitting in the car with her singing along to John Mayer's soulful soft rock album *Continuum*, and how she'd always buy the rap albums he wanted for Christmas.[3] (A devout Christian, she'd buy the versions with explicit lyrics bleeped out.)

In high school, Aminé helped out running the school's radio station, where he and his friends would write lyrics to go over popular rap instrumentals from artists like Future. "We did it as a joke and I realized, Oh, man, this rapping thing's kinda fun. I like writing verses," he says. "After high school ended I was like, I still wanna do this, so I bought some beats from people and kept trying to make it happen." In case it didn't work out, he enrolled in college, studying marketing at Portland State, but avoided the typical student lifestyle. "I did not party at all," he says. "I was living with my parents, making music every day, trying to figure that part out." This work ethic is another thing inherited from his mother, who worked graveyard shifts at the post office to support the family. "I really want to work myself to the bone—till I'm dead tired and I can't work anymore," he says.

> "*I feel my job as an artist is to always give people what they don't know they need, rather than what they want.*"

The result of these experimentations was a series of tracks that included "Caroline," his breakout hit, which catapulted him out of college and onto the Billboard Hot 100, where it stayed for over half a year.[4] The song hasn't aged a day since, from its spare funk riff to Aminé's acrobatic flow, which dances over the song's slow, loping rhythm.

Every one of Aminé's releases brings something new. "I love looking back at my discography and thinking that none of these albums sounds alike," he says. "I feel my job as an artist is to always give people what they don't know they need, rather than what they want. If people hear an album from you, the next thing they're going to ask is: 'Yo, can you make that again?' And that's not as fulfilling for the artist." So, he followed up *Good for You* with *Limbo* in 2020, a more purist rap record which leans toward colder trap beats and

(3) *Continuum* includes "Waiting on the World to Change," John Mayer's most successful single, both in terms of sales and chart positions. In 2007, it was the most-played song of the year on mainstream adult contemporary radio in the US.

(4) In an interview with *Genius*, Aminé said of "Caroline"—his viral 2017 hit—"I wrote this song with the intention of hopefully making a modern-day 'Billie Jean.'"

(previous)
Aminé wears a jacket and vest by ISABEL MARANT, jeans by SUPREME and shoes by OUR LEGACY.

(overleaf)
He wears a jacket by GUESS USA, jeans by ACNE STUDIOS and shoes by PRADA.

broaches mature topics like systemic racism and the question of bringing children into this broken world. "My whole point was trying to make a classic hip-hop album," he says. (He half-joked when it was released that his feel-good debut had far too many white fans, and *Limbo* was intended as a corrective.)

After each album, Aminé released a mixtape, first *ONEPOINTFIVE* and then *TWOPOINTFIVE*, which he sees as valves to release his creativity without the pressure of making some grand artistic statement. His self-imposed limitation for each of these projects is that he can only spend three months on it and that he must release it immediately afterward. His most recent full-length album was *Kaytraminé*, a collaboration with producer and early Aminé supporter Kaytranada. In 2021, following a period of lockdown-induced depression, the pair rented a house in Malibu and worked every day for two weeks, with Kaytranada making beats during the day and Aminé writing lyrics by night. The result is an unapologetic pool party record suffused with the elation of post-pandemic freedom, including memorable turns from guests including Snoop Dogg, Amaarae and Pharrell Williams.

While Aminé's music stands on its own, he has also gained a reputation for his bold visual imagination, particularly communicated through his music videos.[5] Each clip has a story to tell, with comedic skits, blindingly bright colors and inventive visual gags. They range from low-concept, such as when he and his friends cruise around eating bananas for "Caroline" or play tennis in the pastel-hued video for "Compensating," to the more poignant, like the video for "REDMERCEDES," where Aminé and his friends enter a car dealership in whiteface as a commentary on how wealthy people are treated differently depending on their race.

More recently, Aminé has been expanding into the world of fashion. Not content with being named one of the 10 best-dressed rappers by *Complex*, sitting front row at Jacquemus shows or inspiring Instagram accounts that identify his threads, Aminé has also launched his own merch brand, Club Banana, and recently turned to sneaker design with a series of New Balance collabs.[6] It's clear that his few years of studying marketing didn't go to waste—in a gleeful fit of brand synergy, he's wearing his own-brand sneakers in his recent music videos.

In 2024, Aminé started the Best Day Ever Fest, a music festival in his native Portland where he performed alongside Kaytranada, BADBADNOTGOOD and Toro y Moi.[7] Some eager fans drove 30 hours just to see him play. He relocated to LA a few years ago, however, to be closer to the music industry and other business opportunities (though he also says trading decades of Portland's "depressing weather" for Southern California sunshine sweetened the deal).

(5) Aminé's videos have also received praise from his peers, including Kendrick Lamar, whom he met for the first time in 2021. As he told *Complex*, "He walked up to me, and he was like, 'Yo, I fuck with the creativity in the videos....' He was talking to me in a very serious voice. It was like Yoda telling you that you've got the right path or something."

(6) Aminé's latest collaboration is on New Balance's 740v2 model, which he named the "BTEE740" in honor of his high school, Benson Tech, acknowledging the impact it had on his start as a rapper. The sneakers draw inspiration from the school's royal blue and orange colors.

FEATURES

I WASN'T FLIMSY ABOUT ANYTHING, AND I ALWAYS GAVE IT MY ALL.

(opposite)
Aminé wears a hat by ABELA023, sunglasses by JACQUEMUS, a coat by GUESS USA, a shirt by AFB, trousers by ISABEL MARANT and shoes by OUR LEGACY.

He lives there alone with his goldendoodle, Oliver. "I'm not one of those rappers who gets rid of my dog," he says, laughing. He treats Oliver like a child, and his family follows suit.[8] "Whenever I'm on a long tour I'll fly my dog to Portland to stay with my parents, who treat him like a grandson."

In terms of home life, Aminé says he struggles to keep a daily routine apart from his morning coffee and cigarette before he goes to record at the studio. He calls it a "real single lifestyle," pronouncing the words in an uncharacteristically dejected way. "I recently went through a breakup after a long-term relationship. The single lifestyle as a 30-year-old man really isn't my taste, I don't love it as much, but yeah, I'll figure it out." Now he sits in a rare moment of silence, the strips of sunlight flashing across his face. He says that turning 30 this year has made him come over all reflective. "You start realizing: Man! I can't bullshit no more!"

Is he starting to think more about his musical legacy? "I think about that every day with every decision I make," he says. "I want people to know that I really cared about every creative decision, to know that I always made an effort, that I wasn't flimsy about anything, and I always gave it my all and didn't take any of it for granted." He might be known for his humor, but Aminé clearly means this deeply. Suddenly his gaze shifts out of the car window, and he unclips his seatbelt. On to the next thing. He's got a plane to catch.

(7) Tickets for the Best Day Ever Fest sold for $175–$250. The festival took place on the historic grounds of McMenamins Edgefield, a 74-acre resort in the Portland suburb of Troutdale, and is planned to return in 2025.
(8) Aminé runs an Instagram account for his goldendoodle, @oliverthemenace. He told the zine *Dog Bag*, "The emotional support Oliver provides clears my head… which then leads to my best ideas."

Words
Mark Baker
Photos
Marina Denisova

HOME TOUR: Vila Volman

Commissioned in 1938 by industrialist Josef Volman in Čelákovice, a town 15 miles east of Prague, Vila Volman is a pioneering example of Czech functionalism and shows the influence of the daring artistic avant-garde of the time. Yet its groundbreaking architecture was quickly overshadowed by the invasion and occupation by Nazi Germany in 1939, the year the house was finished. Repurposed during the communist period that followed and then abandoned, the home was nearly lost; it is only now, after years of painstaking reconstruction, that Vila Volman is being recognized as a key part of Czechia's modernist legacy.

The antecedents of the villa's design can be traced back to the Bauhaus school in Dessau, Germany, almost two decades earlier. There, the overriding impetus had been to simplify architectural design to the point where a structure's aesthetic merit was judged chiefly on its ability to articulate function, its form pared back to the essentials. By the time Volman began thinking about building a residential villa befitting the founder of a successful machine tool company, functionalism had become the reigning architectural style in what was then Czechoslovakia.

Socially conscious planners of the era were quick to seize on functionalism's promise to deliver aesthetically pleasing, high-quality buildings at scale and lower cost. For open-minded wealthy industrialists like Volman, functionalism also offered the opportunity to acknowledge this social imperative while building eye-catching houses that met new, emerging standards for style and beauty.

Vila Volman is true to these functionalist roots. Designed by two young, inexperienced architects, Karel Janů and Jiří Štursa, the house bears an uncanny resemblance to Villa Stein de-Monzie—a modernist icon built for the brother and sister-in-law of writer Gertrude Stein near Paris in the mid-1920s. In fact, Villa Stein de-Menzie was designed by the Swiss-French architect Le Corbusier as he was formulating the tenets that would come to define modern architecture.

Both Janů and Štursa admired Corbusier, and at Vila Volman his influence is evident at first glance: the horizontal orientation; the thin strip of windows running across the second level; the facade that functions independently of the house's internal structure; the garden setting (here overlooking the Elbe River at the back of the house) and rooftop terrace. Inside, the interior unfolds freely. In Corbusier fashion, supporting pillars have replaced the traditional load-bearing—and sight-blocking—walls. The result is an airy, oversized ground-floor living and dining room, warmed by sunlight streaming through a long bank of windows on the house's southern side. It functioned as both a venue for Volman to entertain clients and as a place for dinner and after-dinner amusement. The room's sheer size was pioneering.

As with the Villa Stein, the living space was confined to the upper levels, where there were bedrooms and bathrooms for Volman and his daughter, Luďa, as well as a guest room and study. The rooftop space above this, the "Belvedere," afforded pretty views over the river and surrounding countryside, and space for a Corbusier-inspired rooftop garden.

(above) The exterior of Vila Volman features intersecting balconies, staircases and walkways.

> "It's a monument to that heady time in the 1930s when orthodox functionalism flirted with the avant-garde."

What separates and elevates Vila Volman, however, is the way the house's design subtly evokes then-fashionable aesthetic trends, drawing on Cubism, Constructivism and surrealism. By the 1930s, luxury materials such as expensive stone, marble and wood paneling—promoted by architects including Adolf Loos and showcased in Mies van der Rohe's celebrated Tugendhat Villa in Brno—had already become de rigueur in Czechoslovakian mansions. The Volman villa was no exception, with high-quality Italian marble used for the first-floor fireplace and bathrooms.

But Janů and Štursa's design took functionalism a step further, gently suggesting the influence of Czech artists, photographers and graphic designers who were then in thrall to the Europe-wide avant-garde. The playful colors on the walls—pastel greens and a deep salmon pink—seem pulled straight from the canvases of surrealist painters like Josef Šíma or Toyen. The angle of the main staircase to the living quarters plays tricks on the eye—squint and one might be looking at an arty, abstract photograph from the period. The villa's overall shape resembles a luxury ocean liner, a cherished object for Czech modernists.

Adam Štěch, an architectural researcher, cites the influence of the Czech writer and critic Karel Teige, under whom Janů and Štursa studied. Teige himself was a strong proponent of orthodox functionalism, what he called "scientific functionalism," but is better known in the collective imagination for his bold graphic design and collage art. His work typically juxtaposes geometric shapes and lines with subtly sensualized photographic images that almost seem able to penetrate the subconscious mind.

Štěch says Teige's work encouraged the architects to introduce a more expressive aspect to the design—an "emotional functionalism." "There's a visual joy to the villa," he says, pointing to details like the playful circles carved into the main stairway banisters and the unusual, organic angles formed by the ground-floor walls. Stare long enough at the external staircase at the front of the house—particularly the striking way in which the horizontal and diagonal lines intersect—and it could easily feature on one of Teige's book covers.

Volman was not able to appreciate the house for long. He died in 1943, his machine tool company having been partially co-opted for the German war effort. His daughter and son-in-law, Jiří Růžek, continued to live in the house, but with the Beneš decrees of 1945—which placed Volman's company under state ownership—and the coup in February 1948 that brought the communists to power, Luďa and her husband chose to emigrate to France. Luďa succeeded; Růžek was arrested and imprisoned. The two would be separated until 1968, when Růžek was finally permitted to leave. Luďa passed away in 1982, while Růžek lived until 2010.

During the communist period, Vila Volman functioned as a kindergarten, but despite being added to the Central List of Immovable Cultural Monuments in 1979, the house fell into neglect following the 1989 Velvet Revolution. During the 1990s, the abandoned villa was frequently looted and nearly torn down. Efforts to save it began in the latter half of the decade when a group of local businessmen purchased the house and began searching for a design firm that could restore the villa while respecting its immense design heritage. They eventually selected TaK, a Prague-based architectural studio led by Marek Tichý.

Their careful renovation took nearly two decades to complete and Vila Volman reopened to the public as a cultural center in 2022. That same year, the villa joined the global network of Iconic Houses, linking the most important 20th-century homes around the world. It is now beginning to reassert its place as a landmark of Czechoslovakian modernist architecture and a monument to that heady time in the 1930s when orthodox functionalism flirted with the avant-garde to fascinating effect.

KINFOLK

(above) The villa has been furnished with pieces by Czech functionalist designers Jindřich Halabala and Robert Slezák.

FAITH

THE ALTAR OF DESIGN

In Denmark, a community church asked the nation's biggest architects to rethink how faith looks and feels.

Words
Benjamin Dane

Photos
Cecilie Jegsen

As he walks into the nave of his new church in Skanderborg, central Denmark, Kristian Skovmose feels a profound sense of his community. Above him, mighty pine beams span the open square space. Sunlight filters through floor-to-ceiling windows set between colonnaded walls, illuminating the stone altar, the pulpit and the slim wooden chairs arranged in a circle around the central feature: a modest pillar-shaped baptismal font made of stone.

For Skovmose, a 61-year-old local priest who has served this 20,000-strong parish in East Jutland for nearly a decade, this layout holds deep symbolism. "In our Protestant tradition, no ritual is more important than baptism," he says. "It's the axis around which everything else rotates, both in our faith and here in our new church."

The baptismal font is the one permanent fixture in Højvangen Church, grounding the entire space. Everything else can be rearranged to meet the needs of its congregation, including the pulpit from which Skovmose will deliver his sermons when the church officially opens at the end of 2024. Unlike in older, traditional churches, where the pulpit looms above to signify the authority and centrality of God's word, Skovmose will stand on the ground, his feet planted firmly among the people he serves, symbolizing that he is their equal. "I hope people will feel close," he says, "not only to me as the priest but to the congregation as a whole."

The idea of building a church in the Højvangen district of Skanderborg dates back to the late 1960s and early 1970s, when development began in the area, but plans were shelved due to a lack of funding. A small church center was built in 2010 to host sermons and other activities, and as the population of Højvangen grew the need for a larger, more permanent space became evident (around 80 percent of Skanderborg parish are currently members of the church).

The parish council opened a design competition for the church in 2020 and a year later chose a community-centered proposal by Henning Larsen Architects, a Copenhagen-based firm with prior experience in church projects. Greta Tiedje, associate design director at Henning Larsen, describes designing churches as an architect's dream: "The church remains one of the most important cultural institutions in the Western world and one of the few spaces free of commercialization," she says. "Few other projects allow us, as architects, to have such a profound impact on a community and people's lives."

Departing from the traditional cruciform layout with a pedestal-mounted altar, the architects introduced a more democratic design that has no distinct front or back. "We opened and rotated the typical heavy church walls, incorporating expansive glass facades to open up the church to its neighborhood on both a physical and symbolic level," explains Tiedje. This innovative approach, she adds, reflects the evolving role of the church, which today functions not

100 FAITH

FAITH

> "Few other projects allow us to have such a profound impact on a community and people's lives."

only as a space for religious rites, but as a flexible community center, hosting concerts and lectures that are open to people of all religions and none, alongside traditional Christian sacraments.

The design is not, however, a complete departure from traditional archetypes. The architects drew inspiration from the layout of the Dura-Europos church, the oldest known Christian house church, which was excavated in Syria in 1933. The modest home had been converted into a secret place of worship in the 3rd century, when practicing Christianity was still illegal in the Roman Empire. Archeologists uncovered a baptistry, a teaching room and a church hall, but found no prominent altar and only modest decorations. Unlike the monumental structures that would later come to define church architecture, this was a humble, domestic space, prioritizing community and connection over grandeur. "In this sense, we're also revisiting the church as part of an ecosystem rather than positioning it as an isolated, holy sanctuary," Tiedje explains.

From the nave, there is a view of the woods to the north, the freestanding 60-foot-tall bell tower and the nearby cemetery. Seating niches on all sides of the building offer spots for small gatherings or moments of solitude, each with a view of the natural landscape. Lighting and acoustics are controlled by clever use of wood mesh sunshades, and traditional natural materials—such as brick, ash and brass—have been used throughout. The architects aimed to make the space feel more like "a clearing" in the building, as Tiedje says, rather than an actual room.

Henning Larsen were able to realize their original vision in its entirety, ensuring that every element, from architecture to interior details, contributed to the goal of making the space feel modern, accessible, sacred and enduring. "It's rare in Denmark to oversee every aspect of a church project," says Tiedje. "Usually, the design of the liturgical furnishings is assigned to an artist, but here we've been allowed to create a complete, cohesive expression."

This extends to the church's chairs, which were designed by Henning Larsen in collaboration with the Danish furniture maker Brdr. Krüger. Jonas Krüger, fifth generation of the family-owned company, explains that the designers initially explored more decorative forms, such as bentwood elements reminiscent of Viennese chairs, but ultimately opted for a more ascetic design to better align with the church's architecture and overall philosophy.

"We were very conscious of the heritage we were engaging with," says Krüger, sitting in the Henning Larsen offices in Copenhagen. "Danish church chairs have a legacy of simplicity and humility, rooted in democratic and honest design. The challenge was to create something timeless that resonates with our contemporary era without being overly tied to fleeting trends."

The resulting stackable chair is crafted from solid ash wood with a soap-treated finish. In total, 305 chairs have been made for Højvangen, but the Ekko chair—named after the Danish word for "echo"—will also be put into production and sold commercially.

Krüger explains that one of the biggest hurdles of the design process was ensuring the chair was durable and versatile enough to accommodate the various activities of the church while maintaining its minimalist aesthetic. To achieve this, Brdr. Krüger developed specially reinforced mortise-and-tenon joints, ensuring the chair's clean 90-degree angles did not need additional support. "This construction allowed us to strip down the chair to its most essential form—almost naked, as if created with nothing extra. This echoes the idea of faith itself: peeling away layers to reveal the core," says Krüger.

For Skovmose, working closely with the designers and architects on the new church also raised the question of what truly defines a church—both in practical and spiritual terms.

From a Lutheran theological perspective, a church is defined not by its bricks and mortar but by the acts of faith and worship performed within it. Or as Skovmose puts it: "According to Martin Luther, the church could be a barn." This might seem paradoxical given that the Skanderborg Parish Council has invested 95 million Danish kroner ($13.5 million) in a 16,000-square-foot church designed by an internationally renowned architecture firm. Yet it turns out Skovmose doesn't entirely agree with the father of his Protestant tradition: "While some may argue the space itself doesn't matter, I believe it does," he says. "A room that feels special—a space where you sense grandeur and silence—can speak to our religiosity and enhance the experience of faith and worship."

Højvangen will bring the total number of churches in Skanderborg up to three: Skanderup Church, one of the oldest churches in Denmark, was built in the 12th century, and Skanderborg Castle Church followed in the 17th century. In keeping with tradition, stones from both churches have been embedded in one of the interior walls as a symbol of the continuity of cultural heritage.

With 500 years between each church, Henning Larsen faced a unique challenge: How do you design a church that will remain relevant five centuries from now, especially when the guiding architectural ambition is to create, as Greta Tiedje puts it, "a church of today." "It's hard to predict how the church will evolve 500 years from now," she says. "But what we can do is look at what has survived in the past and combine it with modern innovation. It's about creating harmony—balancing modern functionality with timeless traditions."

Tiedje points to the material palette of Højvangen, where brickwork—representing a longstanding church-building tradition in Denmark—is merged with biogenic materials such as wood, reflecting a move toward a more sustainable architecture. "I think people today increasingly see themselves as part of an ecosystem," she says, explaining that the church was ultimately conceived as a way for people to connect with nature. "[It's] a space that invites belonging, reflection and connection—a place where people can feel both as individuals and part of something greater."

(opposite) The Ekko chair is handmade at the Brdr. Krüger workshop in Værløse, near Copenhagen.

(opposite) Kristian Skovmose, the priest at Højvangen Church in Skanderborg, which was inaugurated on December 1, 2024.

KINDRED SPIRITS

In rural Britain, a radical
Jewish community is seeking a new
definition of land justice.

Words
Tal Janner-Klausner

Photos
Christian Cassiel

It's October and 50 Jews of diverse backgrounds, ages and relationships with traditional Judaism have gathered to celebrate the New Year at a farm in southeast England. They pray and sing together. They meditate. They walk through the fields. They move between grief and laughter. They bless and eat apples grown on the farm, dipping them in honey from local bees—a symbol of the gift of the harvest and the hope for sweetness in the coming year.

Rosh Hashanah ("the Head of the Year") comes at the start of the fall, when the seasons change and the trees are heavy with fruit. In the Middle Eastern climate, where most Jewish festivals originate, the much-awaited fall rains bring green shoots of renewal after harsh, dry summer months.

There is a deep ecological logic in marking the new year in the autumn and in the prayers traditionally said at this time, calling for rain. But it poses questions for Jewish practice in northern Europe—lands blessed by rain all year round, where fall is a time of hunkering down and preparing for an inhospitable winter. As Psalm 137 asks: "How shall we sing the song of God in a strange land?"

This is the creative tension at the heart of Miknaf Ha'aretz, an emerging community exploring land-based Jewish practice in the British Isles. For its members, every land is holy—not just Israel. They take Psalm 137's two-thousand-year-old question as an invitation for a richer, deeper spiritual engagement with nature both near and far; a call to "sing the song of God" by connecting to and caring for the land and community in diaspora.

> "Much of Jewish practice is deeply grounded in the cycles of agriculture and the rhythm of the seasons."

Sara Moon and Samson Hart grew up in the same Jewish community in Manchester and reconnected years later when they found they had gone in similar directions in life. Today they are friends and collaborators who both work as food growers and run workshops in the green countryside of Devon in southwest England. They founded Miknaf Ha'aretz in 2020 to, as Moon says, "reconcile this split between my Judaism and my love for the wild." The Judaism of their home community was indoors and in texts, "never grounded in the earth"—a result of history, rather than an essential characteristic of Judaism.

"Much of Jewish practice is deeply grounded in the cycles of agriculture and the rhythm of the seasons," Moon says. "Due to displacement and dispossession, often these ritual practices have become symbolic and abstracted. But it doesn't take much to get back to those earth-based roots." She explains that reintegrating Jewishness and nature has been a powerful and comforting experience. "There's something very healing about cultivating belonging in these lands that we have moved to. I need this community. It's the only place where all of the parts of myself feel like they can be pieced together."

Currently, Miknaf Ha'aretz is a geographically dispersed but active community (though Moon and Hart are working on setting up a farm and retreat center). They celebrate Jewish festivals throughout the year, hold virtual learning series about land justice, and produce zines—self-published collections of art and texts that explore themes like homeland, rest and darkness. They also run a family summer camp and a "radical farm camp."

(opposite)
Hart, Moon and Hannah Peers walk through the forest in Devon, near Hart's home on the edge of Dartmoor National Park.

FAITH

"It's five days on an organic farm, tending the land," Hart says when asked what the radical farm camp involves. He explains that it coincides with the garlic harvest—they pick, dry and braid the garlic while singing and learning. "Garlic is one of those plants that we have a strong historical relationship with. Jews, as wandering people, have carried it to many places and it's become sacred. It was common to carry garlic as protection in your pockets—so much so that it was used as a derogatory term to describe Jews: the garlic eaters! So we're reclaiming that." This is part of a bigger picture, Moon adds: "We're learning how to grow food regeneratively, learning about issues in the food system today and how we can meet them with Jewish land justice values."

The foundational Jewish concept of land justice is *shmita*—"release"—the sabbatical of the land. The Torah commands that Jews follow a seven-year agricultural cycle, in the last year of which the land lies fallow. The fruits and vegetables that grow that year can be picked by anyone, whether poor or rich, landowner or landless, and financial debts are forgiven. Seven shmita cycles culminate in a jubilee year, during which enslaved people were set free.

Although it's unclear to what extent shmita was fully practiced, Moon and Hart see its potential as a manifesto for ecological and economic justice. "It's an antidote to an extractive relationship to land," Moon says. Shmita, like the Sabbath, the weekly day of rest, "enforces limits and the times where we have to pause productivity." Hart agrees: "Shmita is full of wisdom about how we can be in relationship with land in the long term. It's about rest for the land but also that people shouldn't be able to hoard resources over time." As well as a road map for responsible land stewardship, shmita promotes collective rewilding—"the land returning to its wild state every seven years as a way for humans to remember that we are wild animals," Hart says.

In Jewish law, shmita applies only to Israel, but Miknaf Ha'aretz celebrates its liberatory potential for all lands, bringing these ideas into a dialogue beyond the Jewish community. They present at agro-ecology conferences, host events with international speakers (from Kurdistan, Palestine, New York, Puerto Rico) and collaborate with other diasporic organizations like Land In Our Names, which promotes access to land resources for people of color in Britain.

This dialogue is part of their commitment to diasporism and *doykeit*—a Yiddish term meaning "here-ness." For Hart, this is "a

> "We're learning about issues in the food system today and how we can meet them with Jewish land justice values."

choice to belong wherever we are, outside of our ancestral homeland. It's an alternative idea of Jewish liberation to Zionism, nationalism or assimilation. It's to say—we have an ancestral story of displacement, we've ended up on this island, and we belong here. We want to be here, and we want to commit to justice here."

This commitment is reflected in their rituals, which are often creatively reworked to adapt to the British countryside. During Sukkot, the fall harvest festival that follows Rosh Hashanah, Jews traditionally pray for rain by shaking a bundle of four plants. These plants—palm fronds, myrtle, willow and citron fruit—are native to Israel and require abundant rainfall to flourish; Miknaf Ha'aretz developed their own tradition of foraging for four native British species instead.

This radical potential of diasporic life is contained in the name Moon and Hart chose for Miknaf Ha'aretz, which is taken from a Biblical verse: "From the edge of the earth we heard singing." "We loved the idea of diaspora being an edge place, and the potent possibility of emergences from the edges," says Hart.

What kind of songs can be heard from the edge of the earth, from strange lands? Moon finds an answer in Psalm 96: "Sing a new song to God." She contends that in reinventing Jewish ritual and changing community paradigms, Miknaf Ha'aretz is in fact deeply traditional: "There's this dance of allowing the innovation to lead us deeper into the tradition. And part of our tradition is like, 'Sing new songs!' The tradition of Judaism is that it's always unfolding."

"I need this community. It's the only place where all of the parts of myself feel like they can be pieced together."

(overleaf)
Hart and Moon perform a mikvah, a ritual immersion in water. Moon wears the ceremonial robes she received upon her ordination as a Kohenet, a Jewish priestess.

WHITE BEIGE MUSTARD & WOOD

COMING IN HOT! IT'S A KOSHERPALOOZA

Meet the husband and wife starting a kosher food revolution from a Long Island kitchen.

Words
Tal Janner-Klausner

Photos
Maegan Gindi

Shifra and Shlomo Klein are on a mission "to bring people together through food." Even if you happen to be meeting with them via a Zoom call—the couple in Long Island, New York, in the middle of the night; you in Jerusalem in the early morning—you have the distinct sense that you are being hosted for lunch. They welcome you with their infectious laughter, regale you with family stories, and rush to show you ingredients from their pantry—each item presented with pride and pleasure, regardless of whether it is a specialty, like black truffle oil or yellowfin tuna, or else more *heimish*, down-to-earth fare, like salsa from Shifra's father.

The Kleins are the founders of kosher food and travel magazine *Fleishigs*, "a non-traditional magazine for the people of tradition" that both represents and influences the colorful, stereotype-busting world of modern kosher food. The magazine's playful approach reflects the couple's nontypical route into the world of publishing: Shlomo, a religious scribe, and Shifra, a teacher in special education, are both from Chabad (ultra-Orthodox) Jewish families. They married and had children but then, as Shifra says, "we got bored."

As dedicated foodies, they subscribed to magazines like *Bon Appétit*, but found that "there was never anything for *us*." Shifra says she felt compelled to close the gap between narrow popular perceptions of kosher food and the innovation and diversity that she was experiencing, explaining that once-insular kosher-adherent Jews are slowly opening up to what's now possible. Kosher food must follow Jewish dietary laws regarding the consumption of certain foods, such as pork and some seafood, and the preparation of others, including separating milk and meat products. Certification practices used to be local and traditional, but today there are specialty kosher brands that import from around the world. Shlomo gives the example of Tuscanini, a company that advertises in *Fleishigs*: "They bring the finest items from Italy to the ultra-Orthodox market. Cold-pressed extra-virgin olive oil, dried gnocchi, balsamic drizzle. Even people whose entire pantry growing up was, let's say, kugel–gefilte fish–chicken soup, they now have a concept of what's out there in the world."

The internet has also transformed access to kosher recipes, and improved distribution networks have brought specialty kosher products to many delis and kitchens. Finding and cooking kosher food, Shifra says, "used to be a challenge, but now it's easier and more accessible. The world is much smaller in terms of interesting products that were never available in the past." Shlomo adds that "the kosher palate also has evolved" thanks to a new wave of dedicated kosher innovators and influencers, of which *Fleishigs* is an important part. "People look at us as a resource for the news of what's going on in the world of kosher," says Shifra. "We influence the influencers," Shlomo adds, smiling.

"People look at us for the news of what's going on in the world of kosher. We influence the influencers."

OFFICE DU SOIR.

Le samedi soir, avant de réciter l'office suivant, on dit le pseaume de David, page 463.

יהוה Le Seigneur est miséricordieux, il pardonne nos fautes et ne nous détruit pas. Il apaise souvent son indignation, et ne laisse pas s'éveiller en lui la colère.

ברכו Louez l'Eternel, lui qui est digne de toutes les louanges.

L'Officiel.

pendant que l'Officiant ci-dessus, les fidèles chantent les mots du Dieu Que le nom du Roi des rois, a été le saint, soit loué et glorifié. Exaltez n'y a premier et il sera le Roi des rois. Chantez Celui d'autre Dieu que lui. Invoquez-le qui trône par son nom divin. soit le gloire de toutes les hautaines Qu'il nom de Celui qui est. Béni soit béni maintenant et éternelle ment.

18*

> "No matter where you are as a Jew, you're celebrating Jewish customs."

There is an important distinction to be made between kosher food and Jewish food. Shifra defines the latter as "telling the story of the Jewish diaspora" and being as diverse as the regions that Jews have lived in—whether that's Eastern Europe, North Africa, Ethiopia, Brooklyn, or the Middle East. Yet there are unifying elements, because "no matter where you are as a Jew, you're celebrating Jewish customs."

Hence, variations on the same theme can be found in Jewish kitchens all over the world. Many will cook stuffed food for the autumn harvest festival of Sukkoth, symbolizing the abundance of the season. For Ashkenazi Jews, with cultural roots in Eastern Europe, this could be kreplach, boiled stuffed dumplings served in soup. For Sephardi Jews, with cultural roots in the Iberian peninsula and the Middle East, this could be *meh'shi*, stuffed vegetables. Similarly, the prohibition on lighting fire on Shabbat (the day of rest which begins on Friday evening), has meant that most Jewish cuisines have some variation of an overnight cooked dish: Yemeni slow-cooked *jaḥnun* pastries, Sephardi *ḥamin* stew with pulses, meat and eggs, and the similar Ashkenazi cholent.

Recent years have seen a boom in Jewish cuisine. A plethora of cookbooks and initiatives are celebrating old traditions and reviving them with an experimental, modern twist. Some are bold newcomers like Gefilteria, a Brooklyn-based project that aims to revitalize Ashkenazi cooking, taking a much-maligned gelatinous poached fish dish as their flagship. There are also veteran writers who have gained new influence, like Claudia Roden, the acclaimed British Egyptian food writer who has been publishing well-researched and accessible cookbooks on Middle Eastern and Jewish food for five decades.

Fleishigs is as much a reflection of this burgeoning Jewish food culture as it is shaping it. "*Fleishigs*" means "meat" in Yiddish, and the magazine is meat and fish heavy. Yet it also showcases many plant-based recipes and meal plans, saying that they're following the food trend of "treating vegetables with as much respect as you would a steak." And while they do feature Jewish food, kosher food can be almost any ingredient or dish, from anywhere in the world, and offers a wider scope—"it's limitless, it's endless!" Shifra says.

As well as offering kosher travel recommendations or a guide to cooking Wagyu beef in the magazine itself, *Fleishigs* is also at the cutting edge of new media food publishing with a kaleidoscope of projects and collaborations off the page. They run participatory cookbook launches (livestreamed on Instagram), host *GLATT*, a podcast, and even run an annual kosher food festival—Kosherpalooza. Shlomo says that at their second event in 2024, "over 4,000 people came. We took a huge space and filled it with food and alcohol vendors." The New Jersey exhibition center where it was held became a microcosm of the world of contemporary kosher food with advice on everything from braiding traditional challah bread and cocktail blending to making plant-based milks.

The Kleins are proud of how *Fleishigs*, over the course of 60 issues, has grown to have a diverse readership that includes Jews from all denominations, Jews who don't keep kosher, and non-Jews. "There is a lot of stigma around the Orthodox community—that we are secluded and not as inclusive," Shlomo says. "That really isn't the case, especially when it comes to food. I'll make a point of bringing people that don't get along to events. I want to sit them next to each other."

Still, the heart of the project remains the magazine. "We pride ourselves on what we call 'ungoogleable content'—things that you can't find online," he adds.

Fleishigs evolved from humble beginnings. Toward the end of our call, Shifra and Shlomo share a photo of the tiny windowless Brooklyn galley kitchen from which they produced their first issue in 2010. Their journey, moving from scarcity to abundance, reflects the story of both the kosher food scene and of Jewish culture more generally over the past 80 years. "Our generation is living post-war," Shifra explains. "My father was the son of a Holocaust survivor. Their generation was surviving. Now my generation, we have the time and resources and access to all these ingredients. We're going to enjoy life; we're going to live."

(previous)
The Kleins prepare a Shabbat meal together, testing recipes in the kitchen of their Long Island home for a future issue of *Fleishigs*.

"I'll make a point of bringing people that don't get along to events. I want to sit them next to each other."

(overleaf)
Shifra lights candles to usher in Shabbat and recites the Hamotzi blessing over the challah. Shlomo recites the Kiddush blessing over the wine, allowing the cup to overflow to symbolize abundant blessings.

THE CHURCH OWES A DEBT

Theologian Ekemini Uwan is holding her beloved church to account over its complicity in racial violence.

Words
Kyla Marshell

Photos
Molly Mandell & James Burke

The biblical invocation to love thy neighbor is at the core of everything Ekemini Uwan does. In her work, the Nigerian American writer, podcast host and public theologian finds ways to celebrate the foundational truths of her Christian faith while still critiquing the church, an institution that used religious doctrine to justify the transatlantic slave trade in the Americas and colonialism throughout Africa—what she calls the "twin evils." To try to amend the long reach of these injustices, Uwan has become a prominent advocate for reparations, including as a charter member of the International Civil Society Working Group for the Permanent Forum on People of African Descent at the United Nations. For her, the concept of reparations extends beyond monetary compensation to the need for religious institutions to acknowledge the widespread harm they have caused. "It is economic and sociological, for sure," she says. "But firstly, it is theological, because [what was done] is a spiritual violation."

KYLA MARSHELL: When you think about the toll of colonialism, what comes to mind?

EKEMINI UWAN: What would Africa look like had our people never been taken? Had our resources not been stolen? Had Africa as we know it not been carved up at the Berlin Conference with these fake boundary lines—what does that look like? How do we enter into our prophetic imagination to go back and to think again? And then how do we look to the future? I just can't get past that injury—of not only those taken, but those left behind grieving the loss of loved ones to the slave trade, and then having to become second-class citizens on their own soil because of colonialism. How we don't have the resources and the finances we ought to have to live abundant, thriving lives. I see that as a great injustice and a great violation of the image of God within Africans and people of African descent.

KM: How did you come to have an understanding of colonialism's influence on Christianity?

EU: Close to 1.2 million Igbo and Ibibio people [Uwan's family's ethnic group], were taken [from West Africa]. After the transatlantic slave trade and years of enslavement, they were then also colonized by the British. So I was pretty keenly aware of the ways that that mapped onto the lives of Nigerians and showed up even in our own family. I'm the descendant of Nigerian immigrants who came to the US in the early 1970s—the first wave of immigrants that came here—but my mom does not have a Nigerian name. That's a vestige of colonialism because the Christian imperialists deemed African Ibibio names to be barbaric. I remember growing up and seeing how worship was conducted and what Jesus looked like, a white man with sandy brown hair. That was the image that was given to them.

KM: You've spoken before about the papal decree of 1452, which authorized the king of Portugal and the Catholic Church to enslave Africans in perpetuity, leading to the transatlantic slave trade. What do you think motivated that?

EU: To devise theology, doctrines and documents that sanction slavery, that allow you to capture people, simply because they're on land that you want to have, you have to see those outside yourself as nonhuman, or less human than you. It's a deep soul-sickness, a deep depravity, to be able to dehumanize people like that, to treat them like chattel, to gift enslaved human beings to another person, to tithe them as if they're a dollar bill. The motivation, of course, is greed, money, land, but ultimately, you also cannot see these people as people, you have got to see them as deserving less than you would want for yourself. And I think that's a grave sin.

KM: What does the church need to do to extend justice to African-descended peoples?

(opposite)
Together with Dr. Christina Edmondson, Uwan hosts *Truth's Table*, a podcast created for Black women who feel alienated by predominantly white Christian spaces.

> "If they followed the church into evil, they can follow the church into good."

EU: The church needs to issue a legitimate, serious confession of sin and repentance. Repentance is to change one's mind about the sin you have committed and to vow not to do it again. But that's not enough. There's confession, there's repentance, but then there's also *reparation*. Our faith actually has reparations built within it—as in, you need to restore the other person to being whole, as they were before you inflicted the harm on them. That would fall under the category of symbolic reparations. Of course, we need material, financial reparations but there also has to be almost like a denouncement of the theologies that sanctioned colonialism and slavery. What does it look like for the church to lead on that, so that the governments in the US, UK, Spain and Portugal; insurance companies and universities (which have already started doing some work); and other institutions that were involved in this wicked, wicked enterprise, begin to follow suit? If they followed the church into evil, they can follow the church into good.

KM: Who have been some of your influences as an intellectual and as a believer?

EU: Definitely my grandma. She was really the first one to teach me and my sisters the scriptures, the importance of prayer and reading the Bible—she still asks! She just was really congruent with her faith. Not perfect, but really congruent, and I appreciated that because I don't feel like I've always seen that. I don't think Christians have always been good at being congruent.

KM: What do you mean by "congruent"?

EU: Actually living and practicing what you believe. My grandma has always been very loving, very kind to everybody. Far too often there are people that don't exhibit that. They profess to have faith in Jesus, yet they don't care about the oppressed. They don't care about the marginalized. It's all about using the faith for their own gain, in manipulative ways to control others. But really—I take my cues from Jesus, the scriptures, the texts and what the prophets say about rulers and oppressors, and even what Mary, the mother of Jesus, says about how rulers will be dispossessed and how she prophesied against empire.

KM: What can everyday Christians do toward that work of repair, reparations, justice, and being congruent with their values?

EU: I think believers need to open up their Bible. Read the prophets, the sections that people kind of skim over. The Books of Jeremiah, Ezekiel, Isaiah, Nahum and Habakkuk—they've got a lot to say about justice. Jesus has a lot to say about justice. I think that believers ought to ask God—what should I be doing? Can you empower me to do so? And even people that are not-yet believers ought to ask what gifts or talents they have that they can take up on behalf of either my own people or my neighbors, near and far.

THE LONG
ARM OF THE AGA KHAN

The Aga Khan Trust for Culture is revitalizing Muslim heritage. In India, *Manju Sara Rajan* explores their latest projects with director *Luis Monreal*.

Words
Manju Sara Rajan

Photos
Vansh Virmani

In India, we live with stories. Tales of djinns and gods, emperors and statesmen, screen idols, crooks and saviors. We like to mythologize our early ingenuity, recite accounts of valor and romance, and lament our defeats, the torments of colonialism and its brutality. And every year, on August 15, we celebrate our collective awakening when, in 1947, as the country's first prime minister, Jawaharlal Nehru, said, the soul of a new independent nation, long suppressed, found utterance.

In the business of creating a new India, many things were neglected, not least among them the buildings that have born witness to our long and complicated history. But reclaiming these symbols of the past is important, for nowhere do the dichotomies of India and all of its contradictions—its resilience, its poverty, its somersaulting technological advancements—intersect as clearly as in our architecture.

I spent two days this past winter in New Delhi with the Aga Khan Trust for Culture (AKTC), which has, over the last few decades, taken on the task of restoring some of these dormant icons through a slate of urban renewal initiatives—a network of sites that now cover 300 acres in the heart of the Indian capital. The project has included the redevelopment of Sunder Nursery, a 90-acre park; the rehabilitation of Nizamuddin Basti, one of New Delhi's oldest settlements; the restoration of Humayun's Tomb (the grandest tomb in the Islamic world before the Taj Mahal was built); and, since July 2024, the opening of India's newest museum, Humayun's Tomb Museum.

It's an expensive exercise. The AKTC is part of the wider Aga Khan Development Network (AKDN), which bears the name of its founder and chairman, the Aga Khan. His Highness Prince Karim Aga Khan is the 49th hereditary imam or spiritual leader of Nizari Isma'ili Muslims—and one of the world's wealthiest Muslim investors.

Nizari Isma'ilis are a relatively small sect within the Shia community, which is itself the smaller of the two dominant branches of Islam—the other being Sunni. Isma'ili Muslims are spread across 25 countries around the world, with large communities in North America, Europe, Asia and Africa. Considering Isma'ilis are relatively small in numbers, its community outreach feels outsized: The Aga Khan preaches the ethical acquisition and use of wealth, and financial aid that promotes economic self-reliance among developing countries and their poorest people. With some 90,000 employees in 30 countries, the AKDN is one of the largest private development agencies in the world, operating 1,000 programs and institutions.

"We work for a common good. We don't distinguish between who we touch with our projects."

And even though AKDN is inspired by the ethics of Islam, it would be wrong to consider this network of agencies in the same way as one would, say, the Catholic Church. AKDN's work requires it to be multicultural, multi-faith and secular. The AKTC, a not-for-profit entity, is one of the nine agencies under the AKDN. As in India, the AKTC has played a visionary role as a cultural partner in many places around the world, including Afghanistan, Bosnia-Herzegovina, Canada, Egypt, Mali, Pakistan, Syria, Tajikistan and Tanzania.

For the past 22 years, the Geneva-based trust has been under the leadership of Luis Monreal, a Spanish archaeologist, art historian and author. His association with the Aga Khan began when he was proposed by the architect Frank Gehry to sit as a jury member for the Aga Khan Award for Architecture, a prestigious prize for building concepts that address the needs and aspirations of societies with a significant Muslim presence. It brings much-needed attention to practices and projects in parts of the world that are otherwise ignored by Western-centric juries. (Similarly, if there is a thread of Islamic motivation guiding the work of the wider AKDN, then it is that it has chosen Muslim-majority countries to work in and focused a lot of its charitable activities on promoting a better understanding of Islamic cultures' contributions to the world.) "We work in many countries where there is no Isma'ili community," Monreal says. "We work for a common good. We don't distinguish between who we touch with our projects."

KINFOLK

145

> "You cannot just create a modern park without addressing the social issues that exist."

Today, we're in Nizamuddin Basti—one of New Delhi's most crowded and impoverished localities. Tetris-like buildings fan out haphazardly around the minarets of Jamat Khana Mosque—the earliest mosque in Delhi that continues to be used for worship. The area is named after Hazrat Nizamuddin Auliya, the revered 14th century Sufi saint, who is buried in a *dargah*, or mausoleum, here. For pilgrims, this is sacred ground. Every day, thousands make their way through the neighborhood's tight alleyways, with an estimated four million visiting the mausoleum annually. Being here feels as though one has stepped back in time, into an Edwin Lord Weeks painting; the air is pungent with a mélange of scents—rose petals and jasmine; fresh greasy snacks; whiffs of attar, garbage and chewing tobacco.

The Mughal dynasty, which ruled over vast swaths of the Indian subcontinent from the mid-16th to the early 19th century, left behind a brilliant smorgasbord of architectural gems—tombs, pavilions and other structures—in the area around Nizamuddin Basti. This is where the AKTC and its funding partners have focused their efforts in New Delhi, running education programs and health-care facilities, and executing major renovation works. Monreal says the work stems from the Aga Khan's belief that "architecture is a service to society."

Since 1997, the AKTC has forged partnerships in India with governments of different political temperaments and with multiple central and state agencies, including the Archaeological Survey of India, the Central Public Works Department and the Municipal Corporation of Delhi. "We cannot as a private institution alone deal with a project of this magnitude. We need a local public partner to be with us during the process," says Monreal. "These partnerships are so important from a citizen's perspective. That's the reason why people are able to enjoy these buildings in the way that they can."

A short walk from Nizamuddin Basti, Sunder Nursery—a 90-acre green haven—unfurls in genteel contrast to the density of the neighborhood's alleyways. The park was established by the British to propagate saplings and experiment with plants imported from other parts of the British Empire. Today, thanks to the AKTC, its design has been reorganized according to the principles of a traditional Islamic garden—geometric and formal—giving a sense of order, with green squares intersected by gurgling channels of water. There are peafowl fluttering about, as though a Mughal miniature has come to life.

Monreal credits AKTC's unique outlook toward these historical projects for the impact they have had on the local community. "Until very recently, many state organizations and intergovernmental agencies thought of cultural heritage as inert assets," he says. "For 25 years, we've been promoting the notion that these are economically viable assets that could generate jobs, socioeconomic development and cultural understanding. Very few entities work in the area of historic cities from the angle of conservation, social development and education, like we do. It's a method that combines all these aspects into one single project that will endure."

In Islam, a desert-born religion, the relationship to water, flowers and trees is symbolic and powerful. In Arabic, there is a word, *jannat*, that translates to "garden" or "paradise"—a stand-in for heaven, the blissful eternal resting place for those who've led a righteous life. This allegoric connection to nature's splendor presents itself strongly in Islamic architecture, and it seems appropriate that the most impactful work done by the AKTC has been its gift of green spaces to places that would otherwise not have them. From Kabul to Cairo, the agency has created and continues to manage parks in parts of the world where they are not a government priority.

The first of these was Al Azhar Park in Cairo, where, in 1984, the Aga Khan, standing on the rooftop of Egyptian architect Hassan Fathy's home and looking out over the city, proposed that he fund the creation of an urban park. At that time, green space per inhabitant in Cairo was about the size of a footprint—one of the smallest in the world. But when Monreal started his job in 2002, almost 20 years later, the park was still unbuilt; the land that had been made available to the AKTC was Al Darassa Hill, a 75-acre high ground filled with rubble and trash. "It became obvious that you cannot just create a modern park without addressing the social issues that exist," explains Monreal.

"These partnerships are so important from a citizen's perspective."

The project kept evolving in scope, with AKTC taking up the rehabilitation of the neighboring district of Darb al-Amar, improving housing and health care while simultaneously restoring historic buildings in the area. "When we started moving earth, 10th century Fatimid and Ayyubid city walls appeared. So, a new element of the project became the restoration of one and a half kilometers of the former ramparts of medieval Cairo," Monreal says. At less than a dollar to visit, it attracts close to two million visitors a year and is entirely self-sustaining.

Al Azhar became a prototype for what is possible in India. Managed by AKTC's India team, which is headed by architect Ratish Nanda, AKTC has not just restored many of the historic structures around Nizamuddin Basti but, through design, created a sort of heritage trail. It has the beginnings of what could become Delhi's version of Central Park.

On a late weekday afternoon, Sunder Nursery is filled with activity. There are picnickers, strolling couples, friends laughing together, a birthday celebration, plus the odd jogger. Even on a day when New Delhi has been in the news for its thick, hazy cloak of toxic smog, Sunder Nursery feels like an alternative, orderly, green reality—a jannat for the living, if you will.

My last walking tour with Monreal and the AKTC team was through the new Humayun's Tomb Museum, just around the corner from Sunder Nursery. It has opened at a critical moment in Indian history. Inside, the tale of the Mughals, their contributions to India's heritage and more importantly, their plurality, is on full display through objects and detailed storytelling. It offers a lively understanding of that dynasty's impact beyond just the Taj Mahal. For a culture built on stories, AKTC is helping Indians understand our own a little better.

(above)
Monreal inside the mausoleum of Mirza Aziz Koka—a prominent noble in the Mughal Empire in the 16th and 17th centuries—that has been conserved as part of the AKTC's work in the Nizamuddin Basti neighborhood of New Delhi.

KINFOLK

153

LIFE AFTER A LEADER

What happens when a founder dies? In France, a Buddhist community is keeping the teachings of Thich Nhat Hanh alive.

Words
Francis Martin

Photos
Courtesy of Plum Village

"It's like going to your grandparents' house." Brother Troi Bao Tang is smiling, his shaven head capped with a soft russet hat, a scarf draped around his neck—measures to keep out the late-autumn chill. Originally from Indonesia, he has lived since 2009 as part of Plum Village, a global Buddhist community headquartered in the Dordogne region of southwest France—a place that, for those who attend one of the monastery's retreats, is apparently akin to visiting a much-loved relative.

"You don't need to do your homework, you don't do many things. When the mealtime comes, the food is ready," says the 47-year-old monastic Dharma teacher, who is also known as "Brother Treasure." There is an expectation that guests will help with some simple chores, like washing dishes, and take part in meditation, but then in the Plum Village tradition there is no dividing line between practical tasks and spiritual practices. The monastery's founder, the Vietnamese Zen Master Thich Nhat Hanh, taught instead that everyday actions could, if approached mindfully, be themselves a form of meditation, encouraging people to wash the dishes "as if giving the newborn baby Buddha a bath."

The three hamlets that comprise the main monastery in the Dordogne are set within a patchwork of fruit orchards and arable land, interwoven with walking trails first traced by Thich Nhat Hanh when he founded Plum Village in 1982. In a Dharma talk, or teaching, recorded before his death in 2022, he reflected on walking as meditation: "You are walking, but you don't feel the need to arrive, because every step you make helps you to arrive in the here and now."

Brother Bao Tang explains that Thich Nhat Hanh found solace in mindful walking after his exile from Vietnam in the '60s due to his opposition to the war—first in the stone corridors of the Sorbonne University in Paris, where he taught Buddhism, and then in the lush valleys of the Dordogne. He would walk slowly, mindfully, and by doing so, was able to "transform all of the difficulties, to have clarity, to think about what he was facing, to clear up the despair," as Brother Bao Tang says. It is a practice that remains part of daily life at Plum Village.

Thich Nhat Hanh's death was a significant moment for his apostles, who call him "Thầy," meaning "teacher." But while his wisdom and magnetism are considered irreplaceable—quite literally, a new leader has not been appointed—his teachings and practices have prepared senior monastics for the challenge of continuing the Plum Village movement.

For Brother Bao Tang, the key to fulfilling Thich Nhat Hanh's legacy is to embrace change: "Change itself is life. Without change there's no life. Even a rock changes every day due to the environment—decaying, but also strengthening." There is, he explains, a danger that people assume a faith like Buddhism, so rooted in ancient teachings, "belongs to a previous generation," that religion is just something we inherit from the past. "This is something that we want to fix. Whether you are white, whether you are a person of color, whether you are this gender or that gender, it does not really matter because every single person wants to know how to love, we want to have peace, we want to have compassion, we want to have a life of happiness."

Brother Bao Tang has become a prominent advocate for LGBTQ+ inclusion in Buddhism, and has encouraged changes to the setup at Plum Village in order to make it more accommodating for transgender and nonbinary people. One of the monastery's three hamlets is designated for the *bhikkhu* (monks) and two for the *bhikkuni* (nuns), with single guests generally expected to stay with their respective gender (couples and families can stay in any of the hamlets). These strictures are, however, relaxed for certain retreats, and spaces for nonbinary people have been established—adjustments that have come about through the energies of a group of queer practitioners at Plum Village known as the Rainbow Family.

> "Spirituality is not something separate from our daily life; it is in the core of daily life, it cannot be separated."

Consisting of monastics like Brother Bao Tang, as well as lay friends and supporters, the group was not formed to "fight for rights or fight for acceptance," Brother Bao Tang explains. "It's more a group where we create a space where everyone knows how to take care of themselves, and are able to come back to themselves and support one another as a spiritual family."

The Rainbow Family is a part of the wider sangha—a term used to describe a Buddhist community. In the Plum Village tradition the notion of the sangha is somewhat amorphous, and embraces new forms of Buddhist community, such as online groups. When the COVID-19 pandemic forced communities around the world to try to find a way to survive, Plum Village was unusually well-prepared: "In 2010, Thây had the idea to have an online monastery to support people who cannot come to Plum Village," says Brother Bao Tang. His foresight meant that Plum Village had a decade of practice in nourishing a dispersed sangha, dialing in on their laptops, before lockdown meant retreats had to be run remotely.

Today around 200 monastics live at Plum Valley, welcoming thousands of guests a year, both online and in person. Despite their spiritual practice, they are far from insulated from stress—running a monastery on this scale involves grappling with emails, spreadsheets and staff meetings. "Before I became a monk I only had one profession, and since I became one I have more than five," Brother Bao Tang says, detailing his teaching responsibilities at the monastery and its international network of Plum village centers, as well as the more physical labor of cooking and cleaning. "There are moments when we need to rush, there are moments we need to be stressful," he says. "But these should be in their proper place, and ultimately contribute to our happiness—for instance, by ensuring that a project is completed well, or a train station reached in time."

Yet, even with these pressures, he says that he feels "more space and more time" when working in the monastery, compared to his life before becoming a monk—he works hard, but with a purpose that perhaps eludes many in secular employment. Brother Bao Tang admits that mindfulness is easier to practice in a monastery, but Thich Nhat Hanh's teaching on mindfulness was intended to help everyone incorporate active meditation in their life, seeing it as a way to enable people to engage fully with the world. "Our teacher always says that if it is not engaged, it is not Buddhism," he explains. "Spirituality is not something separate from our daily life; it is in the core of daily life, it cannot be separated."

It's for this reason that the community of Plum Village opens its arms to all those who seek respite from the world—an embrace that comes with no preconditions: "We are not interested in converting anybody, but for us it's very urgent, very important to bring people to peace and happiness," Brother Bao Tang says.

(opposite)
Brother Troi Bao Tang, who lives at the Healing Spring Monastery, a Plum Village mindful practice center in the village of Verdelot near Paris.

(previous)
The sangha—or Buddhist community—at Plum Village came together in March 2022 to scatter the ashes of Thich Nhat Hanh.

DIRECTORY

162 Field Notes
163 Behind the Scenes
166 Crossword
167 Received Wisdom
170 Seasonal Produce
172 Power Tool

FIELD NOTES

Words:
Amanda Thomson

A guide to the forest in the spring.

The forest is at its best in springtime. Deciduous trees that are bare through the winter, like oak, beech and birch, start to bud and blossom again, their leaves slowly growing and greening to join the viridescence of the conifers. The sounds of the forest begin to change too; the dawn chorus becomes a wonderful cacophony of trills and warbles that starts just before sunrise, when the air is stiller and the male birds start singing to claim their territory and charm the females. It will change again over the months as resident birds are joined by summer visitors.

You'll sometimes be able to tell the history of a forest by the type of trees you come across. Pioneer species are the first to colonize open ground. In Europe these are willows, birch and rowan, and in North America, cedars, aspen and larches—all trees whose seeds disperse easily and can take root in soil that is nutritionally poor, disturbed or damaged by fire. Given time, other species will follow in what's called ecological succession. Another clue is how the trees have grown in relation to one another. If they are of a uniform girth and height and in rows, chances are the forest has been planted. If there is a range of sizes, you're likely walking in a forest with more natural growth and regeneration—ecological succession in action.

Don't forget to look for lichens, such as the beautiful pale gray-green usneas, sometimes called beard lichens, which festoon the branches and are a sign of good air quality. And watch for the first spring flowers: in Europe, snowdrops, crocuses, bluebells; in parts of North America, the skunk cabbage—so called because its unpleasant scent attracts the pollinators it needs to survive. It's one of the first spring flowers to emerge and has an incredible ability to produce heat—thermogenesis—melting the snow to promote early pollination and protect itself from freezing temperatures.

Photo: Richard Gaston

BEHIND THE SCENES

Words:
Elle Hunt

Three questions for producer and songwriter DANIEL NIGRO.

When Daniel Nigro started working with Chappell Roan, she had only one EP to her name and was debating giving up music. Now, after a roller-coaster 2024 that saw Roan's "Pink Pony Club" spend five weeks in the US Top 20, the duo are among the biggest names in pop music, credited with breathing new vim into the genre. Nigro, as a result of his Grammy-winning work, is increasingly in-demand as a songwriter and record producer. "It feels like it's been a big year," he says from his home in Los Angeles.

ELLE HUNT: What does a producer do?
DANIEL NIGRO: That's such a complicated question because a producer can do many things. Some are strictly musical, while others just help the artist get the best version of themselves. I'm somewhere in the middle—there to have conversations and guide a song while also getting in the trenches of the production. I'm always honest with the artists I'm working with—you need to build trust.
EH: How do you balance your own tastes against the artist's?

DN: Maybe it's cliché to say, but I always feel that the artist comes first: What they want creatively is the most important thing. There's a lot of producers who want to have their stamp on it, but it's not about me—it's about the artist and their creative vision. You're there to facilitate the best version of that.
EH: When you made "Pink Pony Club" with Chappell Roan, back in 2019, you were both convinced it was a hit, but Atlantic didn't agree. How did you keep the faith?
DN: That's something I learned over time. Prior to 2018, if a record label told me "That's not right," I'd go, "Okay—I'm not gonna fight it." But I had this moment in 2018 where I made a song, "Castles," with Freya Ridings. It was the first time that I really fought for it because I believed in it. It ended up becoming my first big European hit. After that my confidence grew—I felt I could trust my gut more. I think that bled over into "Pink Pony Club," which we made about a year later: I knew it was good, that I wasn't wrong.

Photo: Peyton Fulford

KINFOLK

DIRECTORY

ON THE SHELF

Words:
Okechukwu Nzelu

Uncovering the hidden human stories in Britain's churches with writer PETER ROSS.

Award-winning journalist Peter Ross is an expert in finding extraordinary stories in unlikely places. *A Tomb With a View*, published in 2020, explored the graveyards of the UK and Ireland. His new book, *Steeple Chasing*, takes British churches as its focus—buildings that have stood for millennia, outlasting wars, plagues, countless monarchs and deep religious schisms. It's a history that could be read in their architecture, but Ross prefers telling their human stories: "There is," he says, "a sort of solidarity that I get from the past. A sense of the worshippers being kind of present even now. There's something quite neighborly about it."

OKECHUKWU NZELU: How did you come to write *Steeple Chasing*?

PETER ROSS: I was planning to write the book before COVID, but started in the early days of the pandemic, when it was uncertain how long it was going to last. I wanted to find something consoling to write about. I think that was rooted not just in COVID, but in the wider political situation and my pessimism about the climate emergency. I wanted to escape the present, to feel comforted and buttressed by the deep past. On a more practical level, it emerged naturally from *A Tomb With a View*: They're both to do with the marks we leave on the earth and stone. It's about trying to say, *We were here, and on some level, we mattered.*

ON: Which writers influence your writing?

PR: I really like Kathleen Jamie and Annie Dillard. I find the old-fashioned tone and style of Betjeman quite attractive, too. And W.G. Sebald describes a feeling of the dead being present in our lives, which is something I feel very strongly. I don't think my books are quite as digressive as his, but I recognize something of my own heart in him. I think he has an elegiac soul. There's a weariness and a melancholy, but also an enjoyment of place and objects, and people and facts that I think we share.

ON: Is there something unique about churches in Britain?

PR: I feel that they express a certain kind of Britishness, and Englishness in particular. It's partly aesthetic. I'm thinking of country churches, village churches. There's something about the flint walls and the tiled steeple and the cockerel weather vane glinting in whatever sun we're blessed to have that summer that articulates a nostalgic, comforting vision of England. And churches are showcases of neighborliness and community, warmth and compassion, which are obviously Christian values but also rural values.

ON: Churches can tell animal stories as well as human ones. What did you discover in the course of your research?

PR: There's something about church cats that's tremendously appealing. I'm very touched by the idea of these animals wandering around these grand, beautiful spaces. [Cats] are uneasy residents alongside bats. Bats are problematic for churches because their urine eats into the historic fabric of the place, and the droppings are unsightly—nobody wants that at their wedding. But I like the idea that churches have become a sanctuary for bats that would otherwise live in old derelict farm buildings that have now been repurposed as holiday homes. One of the great experiences of the book was spending a night in an old medieval church in Norfolk, with an expert on bats. He helped me listen to them on his bat detector, to that incredible noise that you hear as they zero in on tiny flies.

ON: What other surprises did you find?

PR: If you go into Holy Trinity church in Stow Bardolph near King's Lynn, there's a little side chapel where the local landowner family, the Hares, are buried. In a mahogany cabinet, there is a wax effigy of a woman called Sarah Hare, who died in the 18th century, and who said in her will that she wanted to be memorialized by having herself recreated in wax. She's completely life-size; she's got a red damask robe on, and a hood and cloak, and her hair is her own, human hair. And it's realistic—it's in no way a flattering portrait. She's become very dirty over the years. Her cheeks are almost veined with dirt; one of her fingers has been nibbled by mice. But she's got these incredible piercing blue glass eyes. I think she's buried underneath the flagstones at the foot of the cabinet. That's one of the things about churches that I like: They are full of things that would grace a museum but you can go in and have close encounters with them.

Photo: Richard Gaston

THAT OLD TIME RELIGION:
We're heading due Norse.

Mark Halpin

ACROSS

1. Long, tedious effort
5. Trim closely
10. Annoy a bit
14. Artsy LA or NYC neighborhood
15. Mammal packing a small trunk
16. Birthplace of the world's major religions
17. Mythical treasure ship
18. Scrutinizing
19. Classic theater name
20. When the long-ago events of a Norse god's life occured?
22. Train schedule abbr.
23. Mafia boss in a Puzo title (with "The")
24. Garment for Gandhi
26. Actress Elisabeth
27. Beehive or bun, stylistically
30. Quick shot
31. CD follower
33. Metalworking detritus
34. Notable first lady
35. Ungracious behavior from a competitive Norse god?
40. Feedbag morsel
41. Tool whose Latin name gives us "rasterize"
42. Always, to a poet
43. Suffix for a follower or mineral
44. Love for a señorita
45. Throb
48. One on a California football team
50. "Kilroy ___"
53. John in London
54. Talismans that bring a Norse god good fortune?
57. Most-relied-upon
58. The merest soupçon
59. Some MLB stats
60. All over again
61. Sorceress encountered by Ulysses
62. Take a meal
63. Porgy's partner
64. Hitched together
65. Witnessed

DOWN

1. Slowpoke
2. Luft, Doone, and others
3. "Goodness gracious!"
4. Act of kindness deserving of reciprocation
5. Courtroom recorder
6. "Surprise Symphony" composer
7. Samoa's capital
8. Covered with ivy, maybe
9. Units of work
10. Waterbirds' habitat, often
11. Carbon 14 and the like
12. Denture wearer's purchase
13. Elflike
21. "No Smoking" symbol, emoji, or similar
24. Terrier's tether
25. Cake decorator
27. Helper at a wedding or theater
28. Arafat's grp.
29. Risk
32. Polite form of address
35. Cook pasta or eggs, perhaps
36. Visit a restaurant by oneself
37. Keeps saying
38. Victory in the boxing ring
39. Peach or apple sources
46. Jazz great Hancock
47. Weasel's white relative
49. Promises
50. Recoil
51. Played a role
52. German industrial hub
54. Like many a bridal veil
55. Lima and Toledo locale
56. Spock and McCoy's captain
57. Yammer away

RECEIVED WISDOM

As Told To:
Tara Joshi

Musician EDDIE CHACON—one half of '90s duo Charles & Eddie—on his second career in music.

When our first album, *Duophonic*, came out in 1992, Charles [Pettigrew] and I felt like we'd made a beautiful record that really represented us. But the single "Would I Lie to You?" overshadowed the whole album.[1] It was such a huge hit that it seemed impossible to follow it up.

It seems funny now, but our next release, *Chocolate Milk*, was seen as a disappointment because it only sold half a million records. We were perceived as being one-hit wonders for many years. It was sad, and I felt a bit blackballed from the industry to be seen in such a narrow way; something that started out as absolutely euphoric became very discouraging and painful.

I left the music industry and worked as a fashion photographer, then a fashion director for *Autre* magazine. I was finding different creative outlets—at one point I got into historical renovations of early 1900s homes. I never stopped writing songs, melodies and words, but I never thought I would get to make music again.

KINFOLK

What I like to call "career 2.0" started through a chance encounter with Ethan Silverman, who owned Terrible Records. He was interested in one of my best friends, who I was managing at the time, and I thought, Well, if I'm not going to be doing music, I'd like to at least pay it forward and help other artists.

At the end of the meeting, he said, "What's your story?" Then, a couple of days later, he texted me saying, "I have a really harebrained idea—there's this artist, John Carroll Kirby, who's a very interesting record producer, and I think he would really like your story." John started inviting me over to jam, and I would sing these stream-of-consciousness lyrics that became *Pleasure, Joy and Happiness*. That and *Sundown* were kind of flipped soul, celestial, but I started to flirt with my Charles & Eddie roots a bit, because we had been R&B singers. That's what made me want to work with Nick Hakim for [my new album] *Lay Low*.

In any craft, you're working to become fully cooked, and that's an incredibly long process. It moves like molasses. Now, at age 61, things flow out of me in a really easy way—I believe that I'm finally a fully cooked artist. In a culture that worships youth, it's interesting to make records that you'd have to be my age to make.

I'm writing my best work when I'm not working—the best ideas have come to me when I was having fun. My mother would sometimes say, "When you're thinking too hard on things, it's as though you have this gate and it's closed—and even if destiny wants to come in, it cannot. You're in your own way. It will only become apparent when you're relaxed and at peace—that's when your gate is wide open."

It's been important to remind myself through all of the ups and downs that I am lucky that I get to make music. I've never felt a sense of entitlement. I've never felt bitter when the records didn't go my way, whether they were shelved or if I was dropped from a record label. I always thought to myself, Wow, you got to do that.

I wouldn't redo any of it. It sometimes takes a long time for things to play out and for that truth to reveal itself. It may take you a while to see why things went the way they did, but I think everything is a teachable moment. I'm a believer that all is as it should be.

(1) "Would I Lie to You?" was a worldwide hit, and won the 1992 Ivor Novello Award for Best Song Musically and Lyrically.

TOP TIP

As Told To:
Daphnée Denis

Hotelier AMAR LALVANI'S guide to making guests feel welcome.

At its core, hospitality is about making you feel like you're being welcomed into someone's house—you should forget you are in a hotel. My head of design, Verena Haller, knows she's got it right when I walk into a hotel and take my shoes off. I come from an Indian background and it means I feel at home.

The Manner, a hotel we launched in September 2024 in New York, is built around that premise: What kind of intimacy do you experience when staying with a great friend versus staying in a hotel? It starts with the location—the Manner looks like a beautiful residential building—and skipping the check-in process; you just get a key when you walk in. There are no TVs in the rooms and there's a communal area with books about art, religion, philosophy, music, that come from my own collection. The goal is to reflect the complexity of someone's personality, what their apartment might be like. Those details cannot be staged.

Hospitality is not the same as the business of hospitality. Often in the hotel business, it is just about the operation: check-in and check-out times, when breakfast is served…. These are not set according to people's lives but to follow convention, to make housekeeping more efficient. The business of hospitality is about conformity. It should be the opposite; it should be about individuality instead. It should be about the guest.

Ultimately, a hotel should figure out its guests' needs, instead of having the guests accommodate those of the hotel. It may sound simple, but it can be hard to execute.

SEASONAL PRODUCE

As Told To: Apoorva Sripathi

Chef and social practice artist TUNDE WEY shares a recipe.

I like to think of Nigeria (and Africa in general) as a syncretic place—we have a capacity for cosmopolitanism in our food and foodways; we're not just victims of history and circumstance. For us, seasonality is not just about the seasons, it's also about the celebrations we have, like eating ram during Eid or jollof rice during holidays; it's an idea that's better framed around customs as opposed to just seasonal produce or climate source.

This recipe came about for a project I did about death with Yes We Cannibal, an art collective in Baton Rouge. The original dish uses purslane, which I substituted here for fiddleheads, as they are emblematic of spring. The daikon is braised in Malta Goya, a sweet malty beverage that has the same look as stout and which I drunk as a kid at parties in Nigeria at parties to imitate adults drinking Guinness. Here it adds richness to the dish.

Daikon Braised in Malta Goya with Fiddlehead and Mushroom Purees:

Serves 6

6 cups (about 1 pound/450g) diced onions
¾ cup (175ml) coconut oil
8 ounces (225g) cremini mushrooms
5 ounces (150g) iru (or nutritional yeast)[1]
1 teaspoon dried rosemary
1 teaspoon dried thyme
1 teaspoon onion powder
1 teaspoon garlic powder
½ cup (120 ml) olive oil
8 ounces (225g) fiddleheads
12 garlic cloves (6 diced and 6 whole)
Salt and pepper
1 pound (450g) daikon (or spring vegetable substitute), sliced into medallions
1 teaspoon coriander
2 (12-ounce) bottles Malta Goya

For the mushroom puree, in a large skillet, sauté two cups of diced onions in ¼ cup of coconut oil until translucent. Add the mushrooms and season with 2½ ounces of iru, rosemary, thyme, onion powder and garlic powder. Cover and cook over medium heat for about five to eight minutes, until the mushrooms have sweated out. Then uncover and cook over medium-high heat until almost dry (but not burnt). Stir in ¼ cup of the olive oil. Puree in a blender.

For the fiddlehead puree, wash and trim the hard ends (the bottom ¼ inch) from the fiddleheads, and blanch in boiling water for about two minutes, until the fiddleheads brighten in color. Drain the fiddleheads. In a large skillet, sauté the blanched fiddleheads with the six diced garlic cloves and ¼ cup of the coconut oil over medium-high heat until they brown slightly, for about five minutes. Puree in a blender with the remaining ¼ cup of olive oil. Strain through a fine-mesh sieve (discarding the liquid) and add salt and pepper to taste.

For the daikon, in a large skillet, sauté the daikon medallions with the remaining four cups of diced onions in the remaining ¼ cup of coconut oil until translucent and soft. Add the six whole garlic cloves and cook until soft. Season with 2½ ounces of iru, salt, coriander and pepper. Cook uncovered over medium-high heat until the daikon is browned but still crunchy. Add the Malta Goya. Continue cooking, stirring occasionally, for about 20 minutes until the sauce reduces and becomes slightly sticky and the daikon is soft.

To serve, layer a spoonful of mushroom puree on a plate, then add a piece of braised daikon and a spoonful of fiddlehead puree, slightly offsetting each one.

(1) Iru is a fermented locust bean product frequently used in West African cooking, and can be found as a ground powder or whole beans.

POWER TOOL

As Told To: Precious Adesina

Artist ZADIE XA's hog hair paintbrushes.

My relationship with hog hair brushes began in 2005 while I was studying under the painter Elizabeth McIntosh in Vancouver. When people first learn to paint, they tend to gravitate toward softer, more synthetic brushes as they produce a smoother effect. Yet, in all aspects of my practice—whether it's collage, textile assemblage or sculpture—I've always been attracted to processes where you can see the artist's hand. I remember admiring how stiff hog hair brushes were and how they produced this unforgiving mark—you can see a trace of the individual hairs in the brushstroke; they don't hide the materiality of the paint. When you look at my paintings in real life, you really can see the mark of my hand.

While painting as a medium is important to me, it's much more about working with my hands and using it as a means of storytelling. At art school, we were taught to define who we were as artists and what our work was about, and that continues when artists exhibit at galleries and museums. I'm more interested in just exploring color, texture and putting things together—if it happens with paint, that's great, but sometimes it's in textiles.

I recently took about five or six years off painting and focused more on installation works, such as performance and sound pieces. In that time, I forgot about hog hair brushes, but since returning to painting a couple of years ago, I have used nothing else. I'm now realizing they're so much more than just a brush. There are artists who have used the same hog hair brushes for 10, 15 or 20 years. The paint collects at the bottom of the brush, creating this sharp form that you can use to draw into thick paint or various surfaces. It allows you to be rougher and more physical with the surface you are working with.

I'm someone who likes to do whatever I want artistically, depending on the idea I have at that moment. I think about science fiction, novels, fantasy art, cinema, artworks created by my colleagues, performances and video art. But painting always feels like returning to the drawing board for me. It helps me decide what I want to do next.

Photo: Thomas Duffield

CREDITS

RAMY YOUSSEF COVER:	PHOTOGRAPHERS STYLIST GROOMER HAIR PRODUCER	Carlos + Alyse Von Ford Abigail Hayden Andrea Grande-Capone Veronica Leone

Youssef wears an outfit by Bottega Veneta.

FAITH COVER:	PHOTOGRAPHER STYLIST HAIR & MAKEUP ARTIST PRODUCTION MODEL	Michael Oliver Love Chrisna De Bruyn Michelle-Lee Collins Hero Creative Management Kayla @ Topco Models

Kayla wears a dress by Issey Miyake.

RAMY YOUSSEF:	PHOTO ASSISTANT STYLING ASSISTANTS	Teague Shoup Jordan Nasa & Pascia Sangoubadi

GREAT AND SMALL:	STYLING ASSISTANT VIDEOGRAPHER	Brandon Reefe Ryan Janssens

SPECIAL THANKS:		Sarah Aziza Iva Butković Sophie Chamas Aliya Mohamed Benja Pavlin Tara Perez

STOCKISTS:
A — Z

A	&TRADITION	andtradition.com
	ABELA023	abela023.com
	ACNE STUDIOS	acnestudios.com
	AFB	afb-afb-afb.com
	AKJP STUDIO	akjpstudio.com
B	BLUEMARBLE	bluemarbleparis.com
	BOTTEGA VENETA	bottegaveneta.com
	BRDR. KRÜGER	brdr-kruger.com
F	FERRAGAMO	ferragamo.com
G	GCDS	gcds.com
	GUESS USA	guess.com
H	HAY	hay.dk
	HERMÈS	hermes.com
	HOUSE OF FINN JUHL	finnjuhl.com
I	ISABEL MARANT	isabelmarant.com
	ISSEY MIYAKE	isseymiyake.com
J	JACQUEMUS	jacquemus.com
K	KIMONO & SILK	kimonoandsilk.co.za
	KLÙK CGDT	klukcgdt.com
M	MYKITA	mykita.com
N	NANUSHKA	nanushka.com
O	OMEGA	omegawatches.com
	OUR LEGACY	ourlegacy.com
P	PRADA	prada.com
R	RICH MNISI	richmnisi.com
	RICHARD MILLE	richardmille.com
S	SACAI	sacai.jp
	STRING FURNITURE	stringfurniture.com
	SUPREME	supreme.com
T	THEBE MAGUGU	thebemagugu.com
V	VIVIERS STUDIO	viviersstudio.com

POINT OF VIEW

Words:
Lamorna Ash

The writer on her latest residency.

I'm sat in my studio at the MacDowell artists' residency, deep in a forest in New Hampshire. It's the buildup to dusk and the descent into winter and beyond the window, almost every tree has been unleaved—all except for the golden poplar, who has a little more to give.

Last night was the first night I slept here. All the artist studios in the forest have beds in them, but some of these are classed as "daybeds," in which case you are given a second key to a dorm room to pass the nights in. My dorm room is on a second floor, away from the forest, close to the road and lonely. Every time I arrive back there, I immediately miss my studio: the rattling smoker's exhalations of its plumbing, the records on the walls of all the fellows since 1945 who spent weeks in this room dreaming about their art, the inhabitants of the forest that I've observed through my window—deer, bobcats, snakes, chipmunks, squirrels, so many kinds of bird. I slept more deeply last night than I have since I got here. Today I've found it easier to write: part of a proposal for another book, and this piece you are reading now.

MacDowell is the third artists' residency I've been on. To my mind they are invaluable: the chance to dive deep into your work by cleaving yourself from all the commitments and distractions that make up your real life. I started writing my second book this time last year at a residency on the coast in Catalonia. All day I would sit in a studio like this, looking out through a window at a very blue sea as I transcribed interviews with young Christians. After a while, the sincere, whole-souled conversations I was having with the other writers started affecting my work. They made me more porous, more able to appreciate the beliefs of others.

This time I am here to read my way from my last book into my next one. To my left, I have Anne Carson's *Decreation*, for an essay it contains about mystics who perform their relationships to God through autobiographical writing. To my right, I have *Mysticism* by Simon Critchley, and the 14th-century mystic Julian of Norwich's *Revelations of Divine Love*. Anchorites like Julian lived their whole lives in a single room that no other person was allowed to enter. I don't think I could do that, or would want to. It's now 40 minutes until dinner, when I can return to the process of being gradually reformed by the thinking of other artists—writers and filmmakers, choreographers and composers from all over the world—right here in the forest with me.